# MANHATTAN LIGHTSCAPE

MANHATTAN,
*a high narrow kingdom as hopeful as any that ever was, . . .*
*a great and imperfect steel-tressed palace of a hundred million chambers,*
*many-tiered gardens, pools, passages, and ramparts above its rivers.*
*Built upon an island from which bridges stretched to other islands*
*and to the mainland, the palace of a thousand tall towers was undefended.*
*It took in nearly all who wished to enter, being so much larger than anything else*
*that it could not ever be conquered but only visited by force. Newcomers, invaders,*
*and the inhabitants themselves were so confused by its multiplicity, variety,*
*vanity, size, brutality, and grace, that they lost sight of what it was.*
*It was, for sure, one simple structure, busily divided, lovely and pleasing,*
*an extraordinary hive of the imagination, the greatest house ever built.*

MARK HELPRIN
*Winter's Tale*

# MANHATTAN

ABBEVILLE PRESS PUBLISHERS

PHOTOGRAPHS BY NATHANIEL LIEBERMAN

# LIGHTSCAPE

INTRODUCTION BY MARK HELPRIN

NEW YORK     LONDON     PARIS

*for my father,*

# SAMUEL LIEBERMAN

FIRST EDITION

Library of Congress Cataloging-in-Publication Data

Lieberman, Nathaniel.
   Manhattan lightscape/photographs by Nathaniel
Lieberman; introduction by Mark Helprin.
      p.      cm.
   ISBN 1-55859-121-4
   1. Manhattan (New York, NY)—Description—
Views.   2. Manhattan (New York, NY)—Buildings,
structures, etc.—Pictorial works.   3. New York
(NY)—Description—1981-  —Views.   4. New
York (NY)—Buildings, structures, etc.—Pictorial
works. I.   Title.
F128.37.L74   1990                         90-974
974.7'1—dc20                                   CIP

Without MH and PH this book would not
have been. I am deeply grateful for their
support.
   James Ingo Freed has had faith in me for
almost twenty years and has asked of me feats
I would not have thought possible. My vision
of New York was shaped, in many ways, by
his guidance over the years.
   Chris Britz provided inspiration, example,
and impatience with mediocrity. His concern
for me and for my work was instrumental in
the realization of my vision.
   I would like to express thanks to my many
assistants who woke day after day before dawn
to watch the sun rise and feed me film, espe-
cially Leslie Heathcote, Michael Anton, An-
drew Garn, Roy Wright, Arthur Chandler, and
Dane Fitch.
   Bill Kipp, who printed for me for many
years, taught me about color, and Leslie Heath-
cote, Daniel Stern, Peter McClennan, David
Fried, and Dae Soo Hahn, who printed this
work, all deserve my gratitude.
   Jackie Decter, my editor, and Nai Chang,
who designed this book, have done many
things that have amazed me. They have taken
my collection of photographs and made this
book. Throughout this process their judgment
was impeccable and their decisions were bril-
liant and I thank them both.
   And finally I wish to thank my wife, Anne,
whose wisdom and judgment have kept me
on track. Her patience and tolerance were
indispensable to the realization of this project.

NATHANIEL LIEBERMAN

*MANHATTAN LIGHTSCAPE* WAS PUBLISHED
IN CONJUNCTION WITH AN EXHIBITION OF
NATHANIEL LIEBERMAN'S PHOTOGRAPHS AT THE
MUNICIPAL ART SOCIETY'S
URBAN CENTER, NEW YORK CITY,
NOVEMBER 1–DECEMBER 5, 1990.
THIS EXHIBITION WAS MADE
POSSIBLE BY A GENEROUS
GRANT FROM CITIBANK.

EDITOR
Jacqueline Decter

DESIGNER
Nai Chang

COPY CHIEF
Robin James

PRODUCTION SUPERVISOR
Hope Koturo

QUOTATIONS COMPILED BY
Anita Boswinkel-Chang

MAP BY
Sophie Kittredge

# CONTENTS

# CITY OF SUNLIGHT AND SHADOW

Paintings and photographs of New York, perhaps more than those of any other city, can have a remarkable liveliness, as if they actually were moving, as if they were three-dimensional, carried sound, and were not images but, somehow, were real.

Explaining this effect that has permeated the art and history of New York probably since its inception, and that may be as much a part of the magic of the confluence of rivers as it is a gift of the immigrants, is insufficient, for what is truly vital in art or music or a city cannot be explained but only conveyed. Whereas the explainers are damned and forgotten, the conveyors have at least a ghost of a chance.

When academic composers cluster in the front rows of their friends' recitals and follow the scores while using their fingers as pointers, they make the mistake of trying to formulate the ineffable. Once, a musicolgist told me that the beauty of music lies in its mathematical and visual patterns, and that the way it sounds is irrelevant and unimportant. I don't remember the title of the piece we had just heard, but it was something like *Garbage Cans at Night*, and that was a euphemism.

Walt Whitman, Hart Crane, John Sloan, Aaron Copland, Alfred Stieglitz, and anyone else who has conveyed even the smallest part of the truth of New York has known that it is better to sing the city than to explain it. No better gloss for a painting than a poem, no better gloss for a poem than a song. And the city of New York, particularly, is a thicket of emotion and beauty in which theorists get lost like over-equipped explorers in the heart of darkness.

Still, part of its greatness is that even when misperceived it stretches to accommodate a new version of itself. Misperception seems to add another layer of interest and to illuminate by indirection. For example, the *Guide Michelin* declares that "traffic moves smoothly," and "cutting across lanes . . . is frowned upon," and that "The washing of all

that glass is a problem: it's a full-time job, calling for permanent, movable platforms, often manned by Indians." This makes sense, in its way. Similarly refreshing is that, of all the writers who have written about New York, the *Guide Michelin* takes pains to quote one R. L. Duffus. In response, perhaps, a harried New Yorker crafted a report for a Radio Luxembourg interviewer who had called to get a crisis assessment upon the death of Elvis Presley: "Millions of people," he said, his voice blanketing France, "have donned sackcloth, and are keening as they walk the avenues. The Indians are streaming down the Hudson in war canoes, having built sentinel fires as far north as Yonkers. . . ."

The soul of New York, no matter how misperceived, is charitable. It forgives the French, it forgives Franz Kafka's off-target descriptions in *Amerika*, it forgives the tourist on the World Trade Center observation deck, who points to New Jersey and declares it the Bronx. Not only does it forgive, it somehow transforms inaccuracy into accuracy by finding in its vast stores enough material to craft into something that will show it to be whatever it is that someone wants to think it is.

Probably a city that did not exist in so many layers would have great difficulty in finding such infinite possibilities of expression, but New York is like an immense three-dimensional chess game. You must accommodate to the fact that action takes place not only all around you, but also underneath and above, sometimes a hundred layers deep. The stunning complexity is often apparent, but even when it is not it influences the way people think and informs every image of the city, whether intimate or from the air. You must look hard at pictures of New York, for each one has its own language and history.

As languages are grouped in families, so are the portraits of New York. Some, such as John A. Kouwenhoven's *The Columbia Historical Portrait of New York*, or the White and

Willensky *AIA Guide to New York City*, grapple the city's near infinitude like archives. *Delirious New York* gives up entirely and throws itself into the flume. Roger Whitehouse's great collection, *New York: Sunshine and Shadow*, like the work of Jacob Riis, Lewis Hine, and Alfred Stieglitz, finds its power in the expressions of man, woman, and child, with the city around them serving as the book in which are recorded their history and emotions. These photographers and their anonymous colleagues have documented, in their plates of unknown men, women, and children, nothing less than the spiritual history of New York.

Others have portrayed New York thematically—from the air, at night, underground, inside. Agnes Rogers and Frederick Lewis Allen meticulously observed a single day in *Metropolis*. Some, Like Weegee, have photographed not so much according to a theme as according to an idiosyncrasy translated into a pattern of accidents. Others, whom you might presume to have been terribly idiosyncratic, like Jessie Tarbox Beals and her highly-unintelligent-looking assistant, Pumkins, produced as sober and reliable a record as can be imagined. If the enormous numbers of painters, some very great, are included, the visual record expands into yet another universe, but the city can provide whatever material is necessary for its portrayal, from any point of view, by any method, in any medium, entirely without strain.

One of the means of approaching New York has been to do so by addressing its physical form rather than its other attributes. Andreas Feininger and Nathaniel Lieberman are two photographers who have done this most successfully, for they have managed to present the city as an artifact of light and steel, while still conveying emotion. On Judgment Day their pictures will hold their place, whereas those of many others who failed to include the human form will not. What enabled them to accomplish this has been their perfect understanding of several languages in which the city speaks. For Feininger the language was primarily that of perspective, compression, mass, and density. For Lieberman it is primarily that of light.

Though the city can express motion even in stillness, not just any photograph can come alive. The photographer must know how and where to look. He must look in places that have meaning, and those places get their meaning by human association, nothing else, for pure form is a language that conveys human aspiration and sorrow, nothing more or less. The power to express motion even in stillness belongs to the city because it has been invested there by generation upon generation of man, and the suffering, genius, and grace of its inhabitants remain in association with the physical body of New York as if it were a holy place.

Perhaps you have to know the history of the city to sense the presence of the human spirit in the high towers and deft needles that ride in the blue. Perhaps someone you love has to have died there before you can attribute to beams of light across a massive and quiet cityscape qualities other than just those that arise from the laws of physics. Perhaps, before you can hear the music that lifts from the streets, you must be able to search the infinitely detailed cliffs and geometric causeways for the remnants of a childhood entrusted to them long ago. But I think not, for even if memory, love, and regret are prerequisites for understanding the language in which the city speaks, they need not be solely of the local dialect, they can be universal.

You need not know the epic history of the waves of immigration to feel the presence of the immigrants over the centuries. You can feel it, as if by deduction, in the color of the stone and brick tenements, in the way they are arranged in painfully compressed rows, and in the appearance of whole districts, like stone prairies, that in relation to the glowing skyscrapers are as if on bended knee. The colors of these buildings are those that God might have chosen to represent the many millions of lives that have been played out within, in pathos and with difficulty. In New York, even the rich must struggle, and God help the poor. I am reminded of Kipling's description of the trench system of the First World War: "Nothing . . . had been neglected or unforeseen, except . . . the nature of the men who, in due time, should wear their red way through every yard of it." Here the way is not scarlet but brown, and death is slow. Lives are sometimes rewarded and sometimes not, and they reverberate not only in memory but actually in the way the morning sun strikes the row houses of South Brooklyn or the Lower East Side. And for those who view such photographs, in moments of placidity, it is important to know that the waves of immigrants whose spirits colored even the stone are arriving still. History is the same, almost like an immobile image, and yet it moves.

If you view an image of New York it is useful to

understand what, for lack of a better name, I call the level of compression. At street level, as if in the pit of a mine, compression heats the picture and engenders confusion. The lack of open and clear space, the tremendous volume of information in planes and lines fleeing in every direction, the probability of staring into some warren or another (or at least of knowing that beyond and within the jumble of planes at ground level exists an enormous number of others, stretching to what an exhausted mortal might consider infinity), and the weight, both inferred and actual, of everything above, impart to the photograph both a richness and a heaviness of soul.

Aerial views, on the other hand, can be as ethereal as Raphael's sky. Different altitudes bring different effects. At several thousand feet, the image regains its heaviness, because the vast plain of the city—from this height usually gray—fills more of the frame than does the sky. At night the effect reverses, for the source of the light is now at ground level. At dusk and dawn it can go either way. In New York, low-level aerial views from, say, a thousand feet or so, do not require aircraft. A whole school has developed around this altitude, the "Tourismo," mainly because of the prevalence of observation decks and high-altitude restaurants. The thousand-foot perspective requires a master, a master being someone who can make the overdone credible, but, still, it is generally wrong for taking pictures.

The explanation for this is really very simple. The effect follows the same principles that allow an ant to fall ten storeys and stagger away unhurt (should you doubt this, it means only that you have never been a six-year-old boy who lived in an elevator building). The ant benefits from the fact that the molecules of air through which it travels have a specific molecular weight. When he (or she) collides with them, they are relatively more difficult to force out of the way than they would be for a person, and thus provide more braking force. Similarly, the corresponding fundamental units of visual measure in a city do not change. They are window and door frames, cornices, fire escapes, trees, cars, ladders, water tanks, etc. The Tourismo angle makes these details invisible, and the image becomes bland for lack of specificity and means of comparison.

Just as architecture has its golden section, New York has a golden altitude for a golden level of compression. It is between five and twenty storeys, and the ideal height is a function of many variables, including the openness of view,

the lines of the subject, the color of the sky, the amount of light informing that color, and whether the scene benefits from the added depth of a shining rampart of buildings lit simultaneously from within and without. The ideal height and level of compression are due to characteristics of balance. Here you cannot lose sight of the fact that the value of the city is essentially humane, or of the gorgeous and compassionate presence of a soft and perfect sky. You must be able to comprehend the buildings in enough detail to feel their complexity and depth, and yet you must be able to sense their form overall. If you look from too low, you will be overwhelmed. If you look from too high, you simply will not see.

Balance is one of the great hallmarks of the city precisely because the city is the seat of so many contending forces. That it is not ripped apart may be due not so much to action equaling reaction as to divine mercy for a place with the misfortune of being so various and so compressed. As for that divine mercy, probably no textbook on art or architecture exists without the comment that church spires have, from the very beginning, been a symbol of both aspiration and direction, but where does it say that the landscape of New York City is one of towers, needles, spires, plinths, and blazing glass columns that point in the same direction and with much of the same splendor as cathedral towers? Usually, it doesn't say, but a careful observer cannot help noticing that in photographs of buildings and bridges the aesthetic depends largely upon the kind of symmetries (or their deliberate neglect) that the artists of the Renaissance used to illuminate scenes of the Crucifixion or the Last Supper.

Which suggests, once again, light. All of physics, meteorology, geology, and topology cannot adequately explain differences in the light from one place to another. Compare, for example, the light of the North German Plain with that of the Peloponnesus, or that of Birmingham, England, with that of San Francisco. Light is as various as climate or topography, its subtleties, manifestations, and tendencies at least as specific and at least as complex.

Just as the historical school best exemplified by Fernand Braudel explains and depicts the development of civilization in terms of minute transactional analysis, or as Emmanuel Le Roy Ladurie interprets events as a function of climate, or as Marxists see the unfolding of human affairs through the anal peephole of class struggle, it is possible to read a city almost entirely by its light.

You need not forgo the benefits of the other senses, either, because the strength of the light is such that, like music, it can carry virtually any burden of association. Just as images of tenements in shadow or towers in sunlight can convey deeply emotional messages that depend upon knowledge or intuition of events out of the picture, the light that illuminates a scene can bestow upon it many qualities.

We have become used to moving images accompanied by sound, but, before this, their synchronization was accomplished in the mind rather than electronically. The ability to look at an image and, by association, hear music within it and see it move, is a human facility in deep decline, but neither art galleries nor concert halls are fused together in glowing boxes or upon the walls of theaters, so in some places the work of the artist still requires certain collaborative skills from his public. Like the painter, the photographer depends upon the capacity of his audience to make associations, to read the light in its minute variations, to summon music and motion from an image that neither sounds nor moves.

The light of New York is not rapturous like the light of San Francisco, or otherwordly, like the light of Delphi, or perfectly delicate and transparent, like that of Paris. It seems, rather, to be revelatory, dramatic, and argumentative, as if its job were to pull the inhabitants of the city back from their harsher conclusions about the nature of the place, as if its purpose were instructional. The light is as sacred as the action of the streets is profane. It is as gentle as what lies underneath it is brutal. The city may seem narrow, frenetic, and confined, but over this can ride a cool smiling sky that stretches gently to a comforting infinity. Once, I watched a building burn at dusk. The flames were a hundred feet high, the firemen like soldiers in battle, and, as in battle, the dominant colors were red and black. Somehow, the eye supplies these colors in a fight even when they aren't actually there, though in this case they were. To look straight on at the spectacle was to know hell, but after I left and rounded the corner I saw that the open sky, even the part that received the braids of black smoke and white steam from the fire, was the most beautiful and soft robin's-egg blue I had ever seen.

The light can make the featureless gray palisades of high buildings in Manhattan into a concoction of blazing gold too hot to look at and too complex to see, or it can balance the temptations of human pride and vanity in a storm so violent and angry that it makes the nastiest streets seem like gardens. It lights the faces of the people you love, blinds you in certain moments, and restores hope when the daily life of the city takes it away. It has always been the custodian of history, deepening with the passage of time as if it took its beauty not from physics but from the drama of souls. It is possible to study and record the light in the illumination of great scenes and small details, and to read in it not merely messages of pure form, but, rather, the vastly more complicated and consequential presence of mortal man.

It is not just the light and its humane associations that tend to make the still images of this city come alive. The city is structured like a tremendous baffle that traps and converts time. The baffle itself is a weave of complex contending forces. London, Rome, and Paris all present a prismatic view, but they are aesthetic unities (or at least London and Paris have been until fairly recently). New York does what they cannot do, deepens the permutations as they cannot deepen them, because it is prismatic even without the prism. Its distinctions of light, its infinite variations, its symmetries, and the wars among its forms arise not merely from different or changing perceptions, but from the nature of the city itself. Perhaps this is because so much is crammed into it. Perhaps it is because the plan of the streets is structured like a crystal and friendly to echoes, reverberations, and resonance.

If you know New York well enough, and perhaps even if you don't, it seems in some ways to be alive, so that if you write about it you must, in a sense, collaborate with it, and if you paint or photograph it, you must approach it almost as if it were a woman whose portrait would be nothing at all if you failed to capture the light in her eyes.

Its unusual coalitions of form and motion can plasticize time by undoing one's sense of relative proportions. In the first decade of this century, my grandfather took my father into Manhattan, where my father was able to look into a "Kinetoscope." A picture that had theretofore always been still suddenly began to move. For the first time in his life when looking at a picture my father didn't need to imagine the motion or move his eyes. He was too young to know why this had impressed him as it did, but after a lifetime

making movies he understood it very well, and he told me that what had happened was that the terms of history had been rewritten, that at the turn of the century, when he was a boy, the burden of observation had shifted from the observer to the observed. That, for him, was the break, when images came alive not solely by means of human imagination, but in themselves.

The philosophical, social, political, and spiritual implications of this are many, but because New York is a city that, though overbrimming with abstractions, hates abstractions, I will try to develop my point in another story. This time, I was the boy, and I was sailing on the Hudson in a fast and gracefully proportioned wooden boat with a mainsail and a jib. It was June, the weather was perfect, and from the upriver town where I lived I went all the way to Weehawken. The shore came alive as it moved, and the energy and the beauty of the passage—as any touring bicyclist, sailor, transcontinental train passenger, or Mark Twain floating down the Mississippi might attest—were derived primarily from the languid unfurling of the summer landscape.

When I tied up, I expected it to stop, but I hadn't taken proper account of what was across from me. Manhattan was across from me. At its piers scores of great ships were berthed, some awkwardly making their way backward into the channel, some spewing smoke and optically chaotic steam from their funnels. I could see down the length of the cross streets (or at least as far as they rose up the hill), and the great expanse of stone and glass caught the hot afternoon sun as only this palisade can, reflecting it every which way, like the rays of a thistle. The West Side Highway hummed, planes crisscrossed the view, small tugs headed upriver and down. It was moving. It was alive. It had made time plastic because time had been a function of my progress down the river, and, now, even though I was still, the motion continued as the burden shifted from the observer to the observed.

When the burden shifts in relative motion, as in the diagrams that attempt to illustrate the Lorentz transformations, the result is not so simple. Like the spokes in a rapidly spinning wheel, as the perception of time changes, time can appear not only to speed up or go backward, but to stop. If you surrender properly to the whirl of motion in New York, the seemingly chaotic action will cease. That can be very beautiful. It is often the aim or the effect of great art, but if you consider, rather, that—at least theoretically—the phenomenon can be reversed, then you will understand why in a preface to a book of photographs you are reading an essay on time and the city. It is because New York has evolved in such a way that, in its normal, daily operations, it can make the moment stop still. And that is not all, for, in a mirror image of this attribute, the city can bring a frozen image to life as if it actually were moving, as if it were three-dimensional, as if it carried sound, and as if it were not an image but, somehow, real.

MARK HELPRIN
*May 1990*

# 1
## NEW YORK HARBOR
### FROM BAYONNE, NEW JERSEY
### 1981

The beauty of London lies hidden in lonely squares, in unexpected corners of the City, in the Temple, in Chelsea, or Westminster. But New York is seen at its best in the distance, as from the approaching liner, when the clusters of shining, metallic buildings, as tall as and taller than the Eiffel Tower, seem to rise like ascending fountains of beauty.

The liner moves slowly up the broad Hudson River, accompanied by a plaintive choir of gulls floating on motionless wings, until mournful sirens startle them. The Statue of Liberty slips slowly by, that *demodé* but magnificent matron, coppery green, like the doorknobs of ancient country greenhouses. The smooth water, cut by the ship's bows, and the impersonal pageant of passing ships, seem to belong as much to eternity as to a desolate region where mountains lie still for centuries.

CECIL BEATON
*Portrait of New York,* 1948

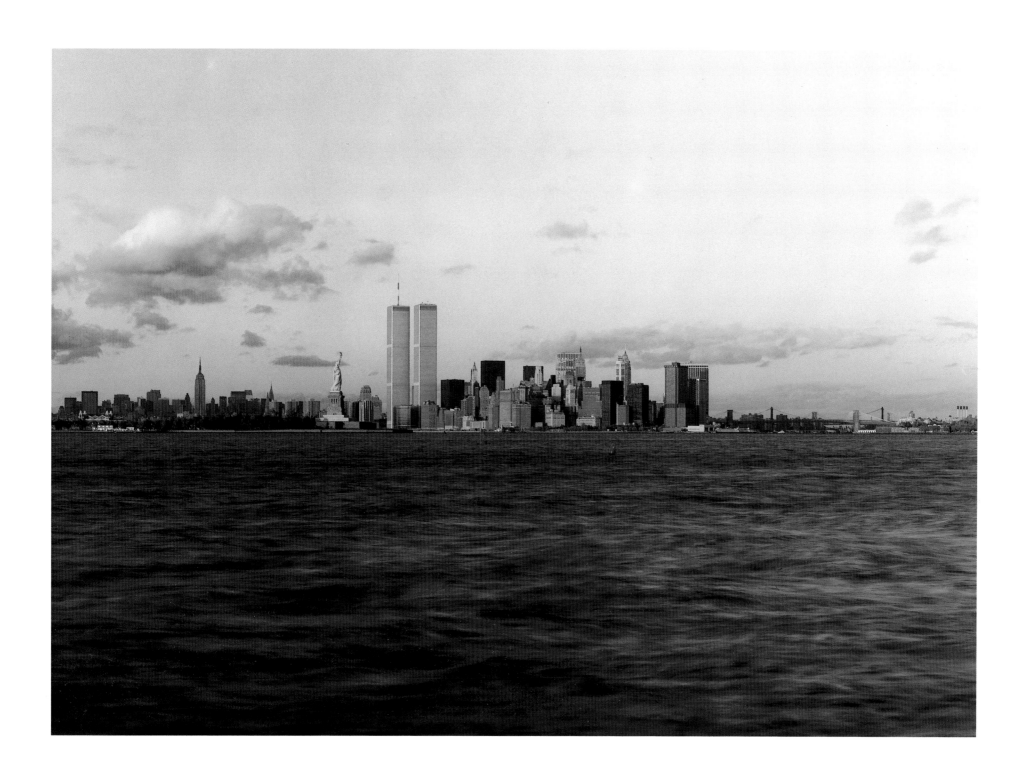

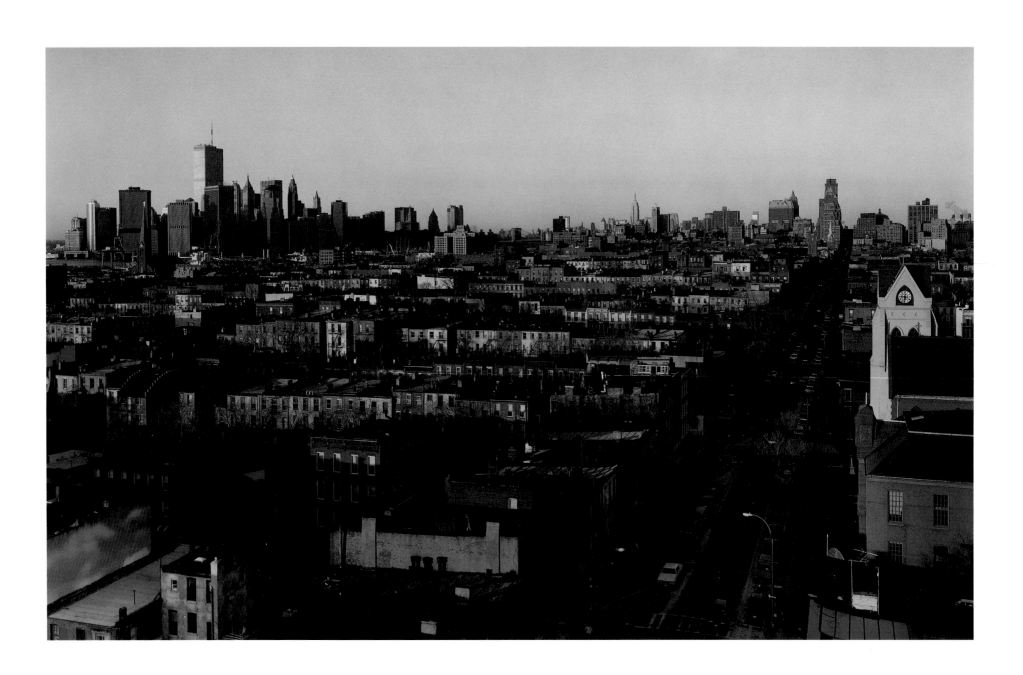

# 2

# CARROLL GARDENS, COBBLE HILL, BROOKLYN HEIGHTS, AND MANHATTAN

## 1989

The view of downtown and midtown New York from Brooklyn Heights beats all. The air is better here. I have no objection to poisoned cities: I live in one. But it is striking, in a salt-water island with the ocean close to its windows, that you do not smell the sea till you disembark at Brooklyn and stand on the Heights. Across water which was usually blue, if filthy, when I was there, you felt you had only to stretch out your hands across the East River to put your fingers into the tills of the Chase Manhattan Bank, so clear was the dry air. Across the water downtown cliffs spread and display themselves in separate pieces. The shapes are still abstract art but here one appreciates the subtle variety of colors. New Yorkers exaggerate nearly everything; but nothing so much as the dirt of their city. No doubt it is dirty, and dirtier than it was—before the motorcar its stone must have been almost in a state of primeval chastity—and we know that Americans have an odd fear of dirt. But how is it that these buildings preserve their whites, their cool grays, their fair yellows and their ochers, their crimsons, their dark grays, and their browns? How freshly the slim-seeming red building at the end of Wall Street stares. From this vantage point Manhattan does not huddle, nor would I have said that it menaced, except as those columns in the account book menace; it displays itself serenely, and Brooklyn Bridge with its stone arches and its harp of steel wire makes the view orderly and momentous.

V. S. PRITCHETT
*New York Proclaimed, 1964*

# DOWNTOWN BROOKLYN AND LOWER MANHATTAN
## FROM THE WILLIAMSBURG BANK
### 1987

The heart of New York is a heart of passion and of song.

Her brain is incandescent. All motion in New York, whether physical or mental, flashes.

The total activity of New York resolved into abstract motion would become lightning.

All energy here is corybantic. All life is nymphaleptic.

Expectancy is on New York's lips and the healthy frenzy for the goods of this world is in her eye.

He who shall write the immortal poem of New York must write it in dithyrambs.

For New York is the Futurist city, the Baden-Baden of that dying stench called Europe, the ironic Gargantuan offspring of the senility, the debilitating spirituality and black breath of the European Succubus.

We in New York celebrate the black mass of materialism.

We are concrete. We have a body. We have sex. We are male to the core.

We have founded our kingdom on the senses, and we glory in it.

We divinize matter, energy, motion, change.

We are the sublime reaction against the bigots and hypocrites who libel life.

We stand a menace and a threat to Europe.

What we want we go and take of you, old Jezebel across the seas! You have sucked the blood out of the whole Caucasian race with your kings and wars.

We of New York shall destroy you utterly, for we are yea-sayers, pagans, world-absorbers.

We take from you what we need and we hurl back in your face what we do not need. Stone by stone we shall remove the Alhambra, the Kremlin and the Louvre and build them anew on the banks of the Hudson.

We are the future. You, old trollop that squats from the Caspian Sea to Land's End, are the past.

Come Europe! Into our melting pot you must go. For we are predestinate, being of this world.

When we visit you it is because we have a fine instinct for slumming.

"New York is hell," some say.

New York *is* hell. All things exist by contrast. And it is because we live in hell that we shall bring forth poets that shall gash the empyrean with their mighty threnodies.

It is because we live in hell that we shall be transfigured.

It is because we live in hell that we shall carry through the coming time fire and flame in our Promethean fennel rods.

The imagination of New York is unkempt, unshorn.

We wear our opinions pompadour.

We are Homeresque, Dantesque, Hugoesque, Whitmanesque.

On the lofty minarets of Manhattan there stands day and night an invisible muezzin who calls the faithful to the worship of Mammon and Speed. For our religion is a practical pantheism, with energy as the Eternal Substance.

We are the super-city. We are the Nibelungen of the West. We possess the Magic Rhine gold, which is the Holy Grail of Man's desire.

We are Gargantua and Siegfried. The old gods across the sea are graying. Already their Goetterdaemmerung has begun.

Come we, the newer Titans: and we are not yet pubescent.

In the fire and fury of our materialism we are dreaming of diviner Brunnhildes, Helenas and Aphrodites.

Out of matter comes mind; out of New York Athens shall rise again!

BENJAMIN DE CASSERES
"New York: Matter Triumphalis," 1925

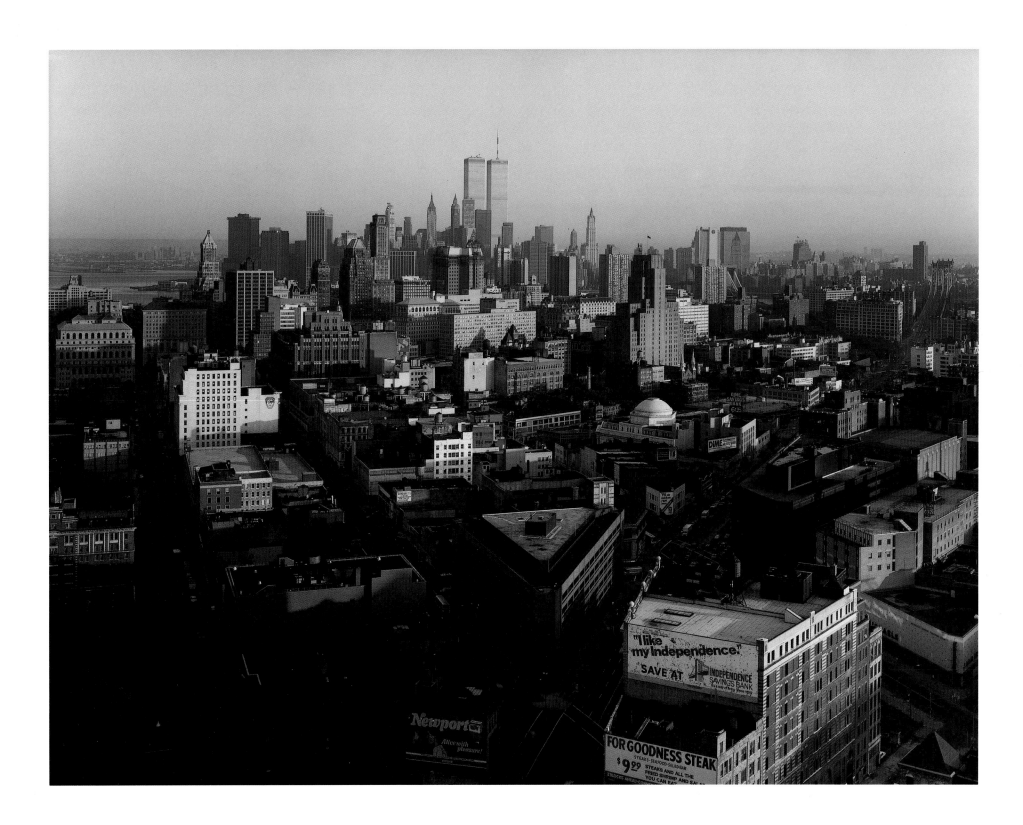

# LOWER MANHATTAN

## FROM CITICORP AT COURT SQUARE, LONG ISLAND CITY
## 1990

Then you remember how a tree that leaned over into the narrow little alley where you lived had come to life that year, and how you watched it day by day as it came into its moment's glory of young magic green. And you remember a raw, rusty street along the waterfront, with its naked and brutal life, its agglomeration of shacks, tenements, and slums and huge grimy piers, its unspeakable ugliness and beauty, and you remember how you came along this street one day at sunset, and saw all the colors of the sun and harbor, flashing, blazing, shifting in swarming motes, in an iridescent web of light and color for an instant on the blazing side of a proud white ship.

And you start to tell your host what it was like and how the evening looked and felt—of the thrilling smell and savor of the huge deserted pier, of the fading light upon old rusty brick of shambling houses, and of the blazing beauty of that swarming web of light and color on the ship's great prow, but when you start to tell about it, you cannot, nor ever recapture the feeling of mystery, exultancy, and wild sorrow that you felt then.

THOMAS WOLFE
"No Door," 1933

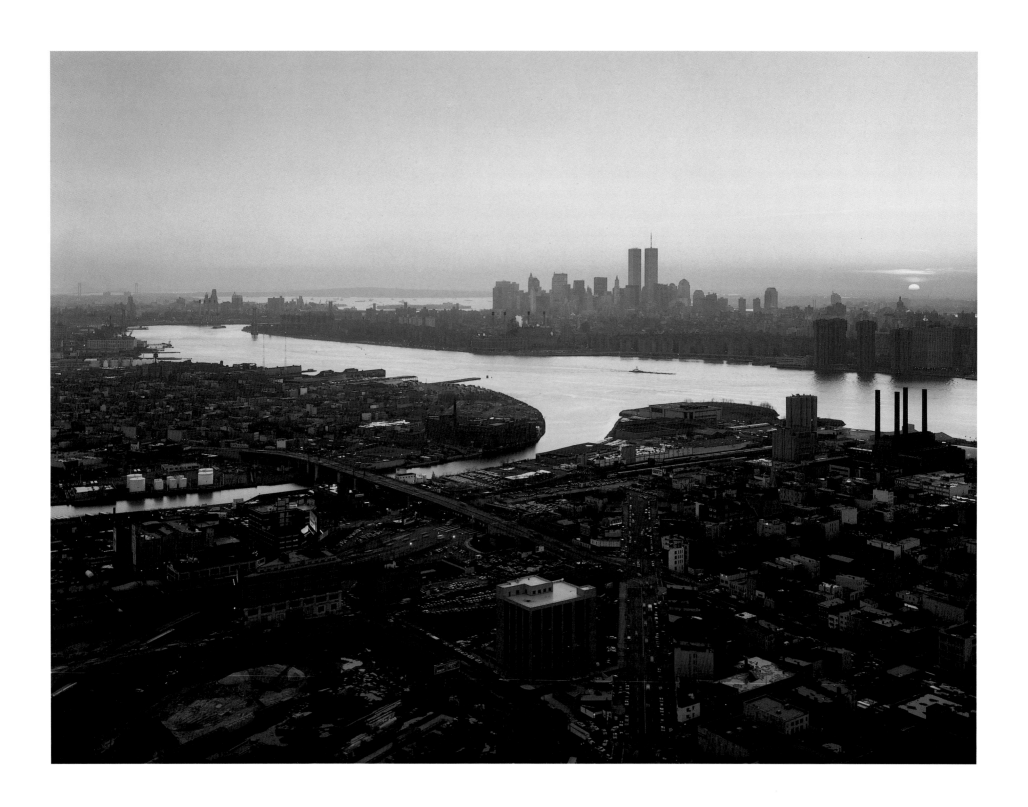

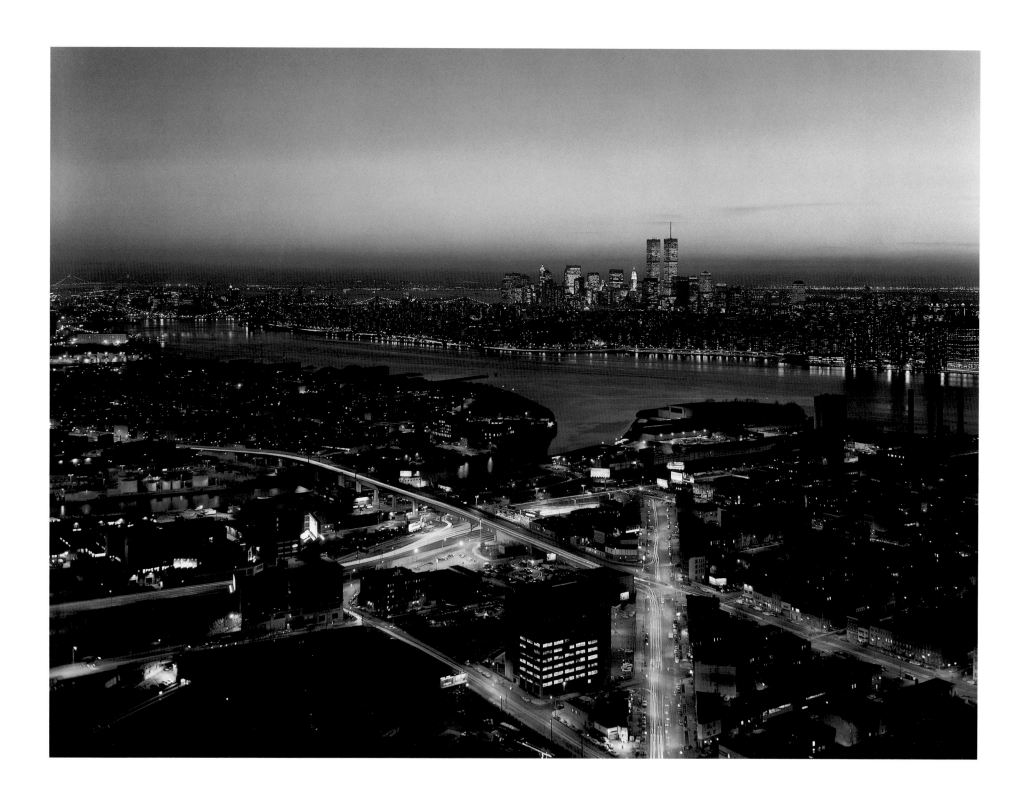

# 6

# LOWER MANHATTAN
## FROM THE BROOKLYN HEIGHTS PROMENADE
### 1973

New York is a vertical city, under the sign of the new times. It is a catastrophe with which a too hasty destiny has overwhelmed courageous and confident people, though a beautiful and worthy catastrophe. Nothing is lost. Faced with difficulties, New York falters. Still streaming with sweat from its exertions, wiping off its forehead, it sees what it has done and suddenly realizes: "Well, we didn't get it done properly. Let's start over again!" New York has such courage and enthusiasm that everything can be begun again, sent back to the building yard and made into something still greater, something mastered! These people are not on the point of going to sleep. In reality, the city is hardly more than twenty years old, that is the city which I am talking about, the city which is vertical and on the scale of the new times.

LE CORBUSIER
*When the Cathedrals Were White, 1947*

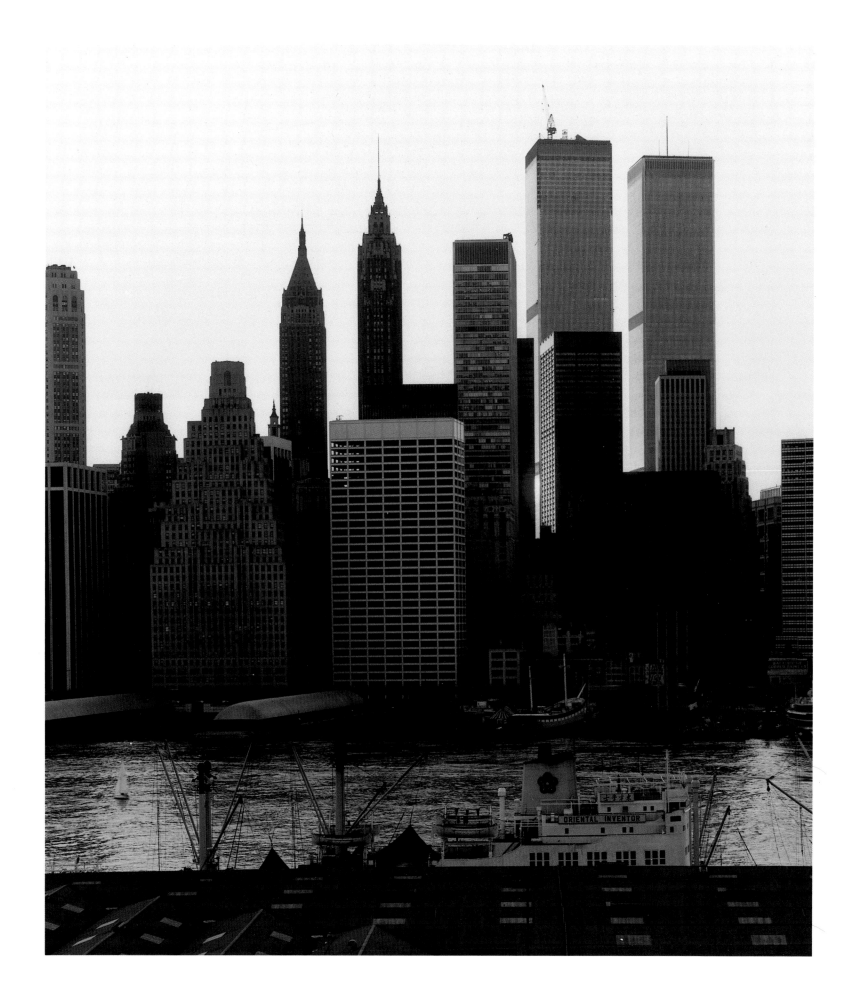

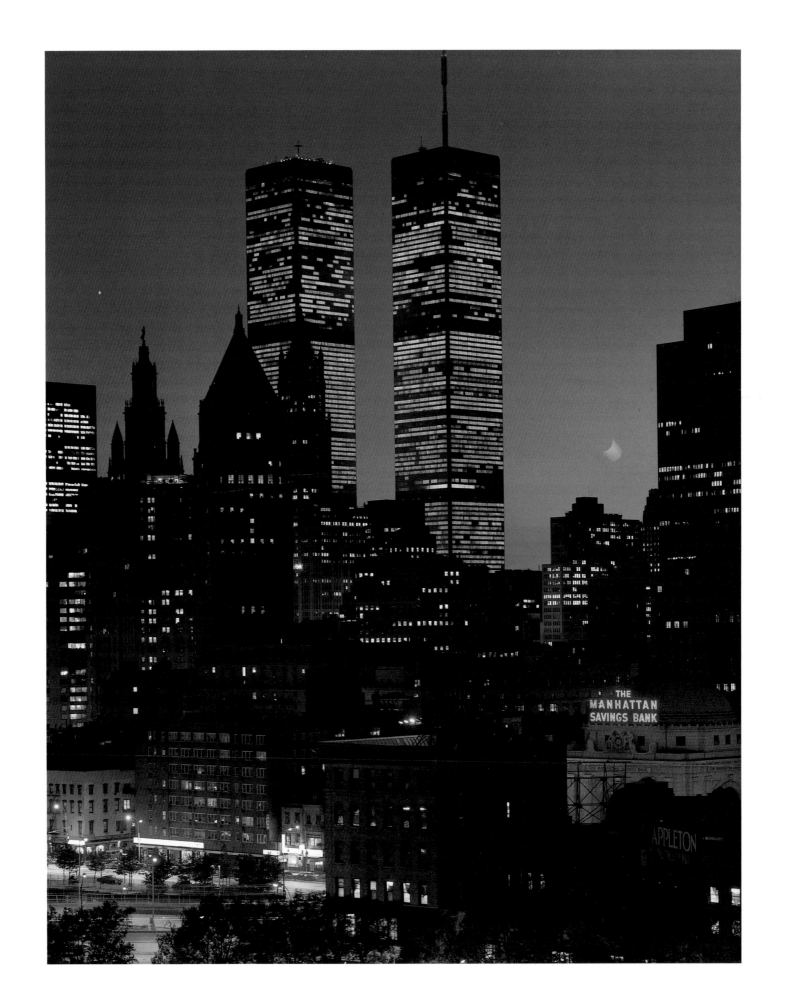

# MOONSET OVER LOWER MANHATTAN

## 1981

A mournful old building stood between two that were tall and straight and proud. In a way, it was a sad thing; symbolizing a decrepit old man whose lean shoulders are jostled by sturdy youth. The old building seemed to glance timidly upward at its two neighbors, pleading for comradeship, and at times it assumed an important air derived from its environment, and said to those who viewed from the side-walks: "we three—we three buildings."

It stood there awaiting the inevitable time of downfall, when progress, to the music of tumbling walls and chimneys would come marching up the avenues. Already, from the roof one could see a host advancing, an army of enormous buildings, coming with an invincible front that extended across the city, trampling under their feet the bones of the dead, rising tall and supremely proud on the crushed memories, the annihilated hopes of generations gone. At sunset time, each threw a tremendous shadow, a gesture of menace out over the low plain of the little buildings huddling afar down.

Once this mournful old structure had been proud. It had stood with its feet unconcernedly on the grave of a past ambition and no doubt patronized the little buildings on either side.

STEPHEN CRANE
"A Mournful Old Building"

# VIEW NORTH ACROSS BOWLING GREEN
## FROM 24 STATE STREET
### 1981

Silent, grim, colossal, the big city has ever stood against its revilers. They call it hard as iron; they say that no pulse of pity beats in its bosom; they compare its streets with lonely forests and deserts of lava. But beneath the hard crust of the lobster is found a delectable and luscious food.

O. HENRY
"Between Rounds"

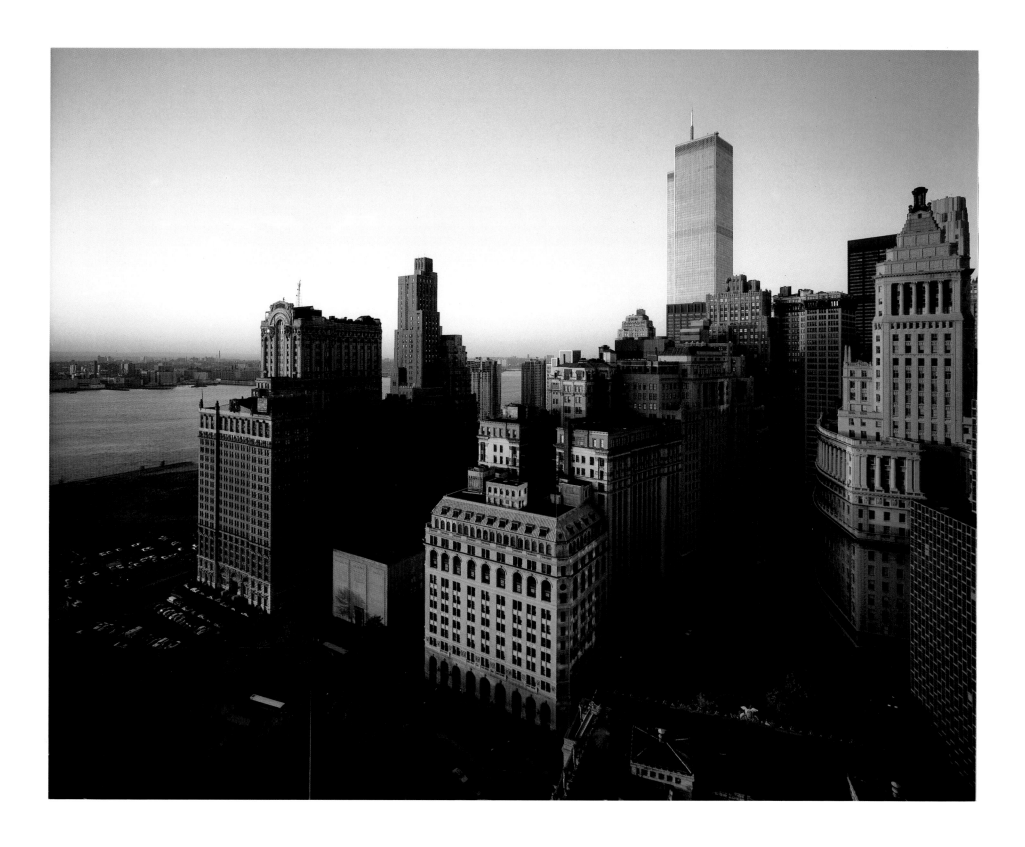

# NEW YORK HARBOR AND GOVERNORS ISLAND
## FROM 17 BATTERY PLACE

### 1985

The car sweeps on its diagonal path through the Tenderloin with its hotels, its theatres, its flower shops, its 10,000,000 actors who played with Booth and Barret. It passes Madison Square and enters the gorge made by the towering walls of great shops. It sweeps around the double curve at Union Square and Fourteenth Street, and a life insurance agent falls in a fit as the car dashes over the crossing, narrowly missing three old ladies, two old gentlemen, a newly-married couple, a sandwich man, a newsboy, and a dog. At Grace Church the conductor has an altercation with a brave and reckless passenger who beards him in his own car, and at Canal Street he takes dire vengeance by tumbling a drunken man on to the pavement. Meanwhile, the gripman has become involved with countless truck drivers, and inch by inch, foot by foot, he fights his way to City Hall Park. On past the Post Office the car goes, with the gripman getting advice, admonition, personal comment, an invitation to fight from the drivers, until Battery Park appears at the foot of the slope, and as the car goes sedately around the curve the burnished shield of the bay shines through the trees.

STEPHEN CRANE
"In the Broadway Cars"

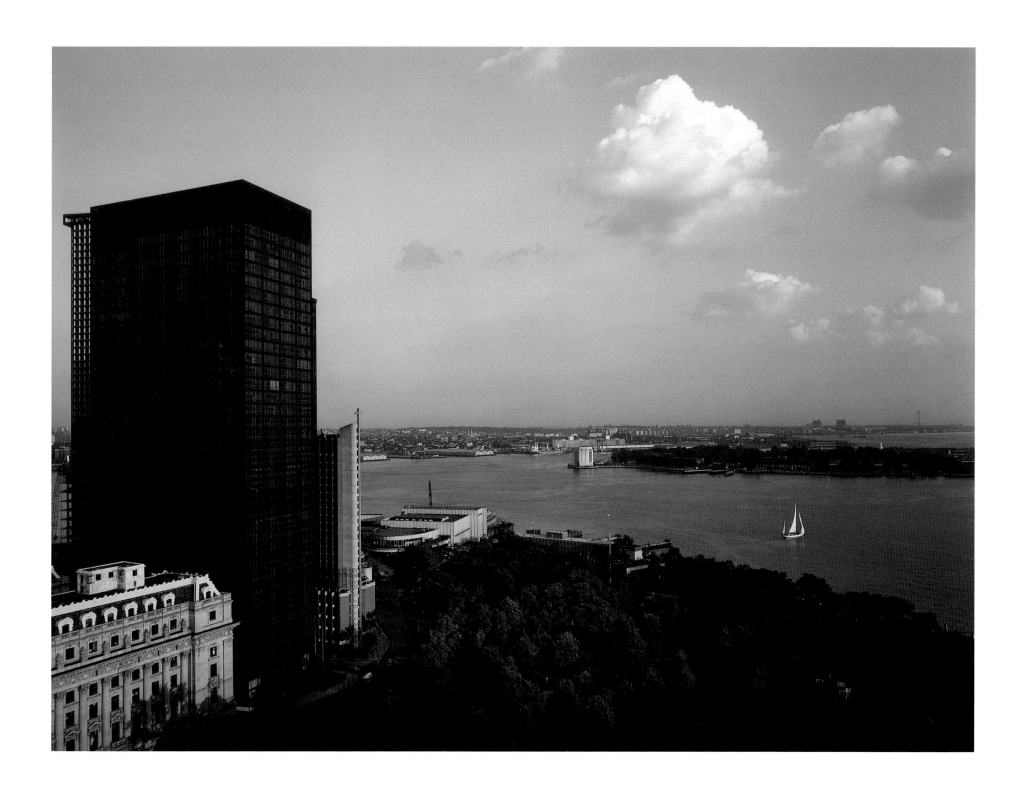

# 10
# EAST PIER OF THE BROOKLYN BRIDGE
## 1985

Hey, Coolidge boy,
make a shout of joy!
When a thing is good
                    then it's good.
Blush from compliments
                    like our flag's calico,
even though you're
                    the most super-united states
                                                of
America.
Like the crazy nut
                who goes
                        to his church
or retreats
            to a monastery
                        simple and rigid —
so I
    in the gray haze
                    of evening
humbly
        approach
                the Brooklyn Bridge.
Like a conqueror
                on cannons with muzzles
                            as high as a giraffe
jabbing into a broken
                    city besieged,
so, drunk with glory,
                    alive to the hilt,
I clamber
        proudly
                upon Brooklyn Bridge.
Like a stupid painter
                    whose enamored eyes pierce
a museum Madonna
                like a wedge.
So from this sky,
                sowed into the stars,
I look at New York
                through Brooklyn Bridge.          CONTINUED ON PAGE 33

30

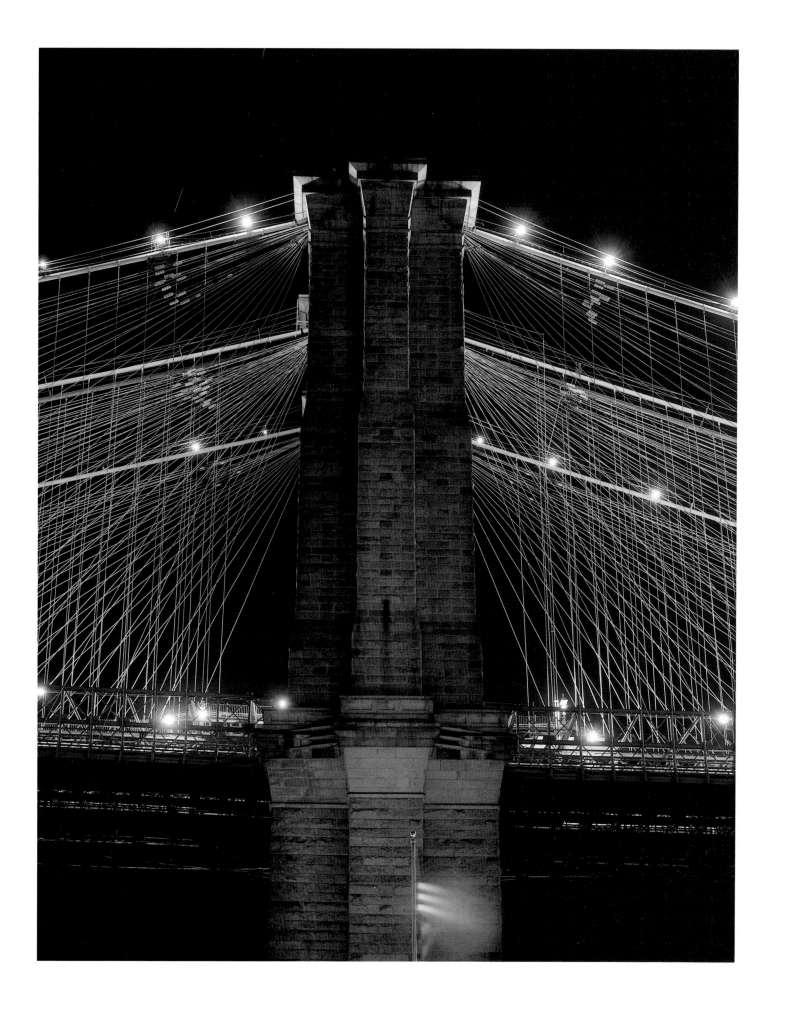

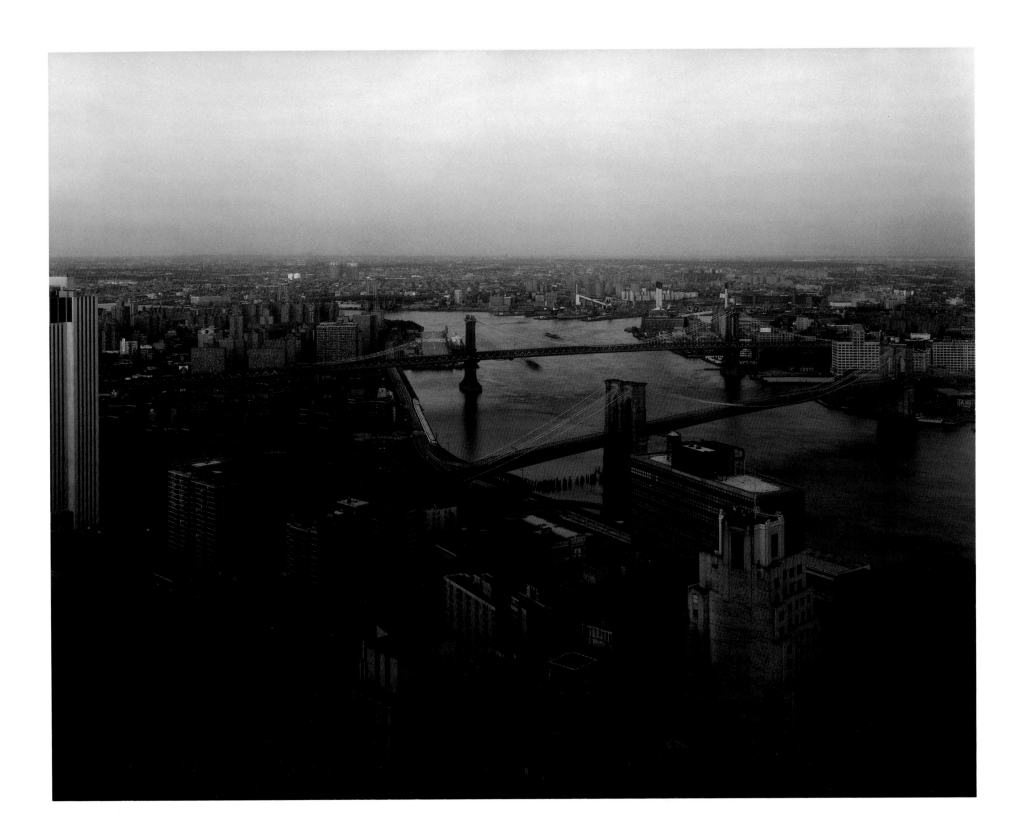

# 11

# EAST RIVER BRIDGES
## FROM ONE CHASE MANHATTAN PLAZA
## 1982

New York,
          heavy and stifling
                        till night,
has forgotten
          what makes it dizzy
                        and a hindrance,
and only
          the souls of houses
rise in the transparent
                        sheen of windows.
Here the itching hum
          of the 'el'
                        is hardly heard,
and only by this
          hum,
                        soft but stubborn,
can you feel the trains
                        crawl
                              with a rattle
as when dishes
          are jammed into a cupboard.
And when from
          below the started river
a merchant
          transports sugar
                        from the factory bins —
then
     the masts passing under the bridge
are no bigger
          in size
                        than pins.
I'm proud
          of this
                    mile of steel.
In it my visions
          are alive and real —
a fight
          for structure
                    instead of arty 'style',
the harsh calculation
          of bolts and steel.

CONTINUED ON PAGE 34

# 12
# THE BROOKLYN BRIDGE CENTENNIAL
## MAY 24, 1983

If the end
        of the world
                comes —
and chaos
        wipes out
                this earth
and if only this
        bridge
                remains
rearing over the dust of death,
then
      as little bones,
                thinner than needles,
clad with flesh,
      standing in museums,
                are dinosaurs, —
so from this
      bridge
        future geologists
will be able
      to reconstruct
                our present course.
They will say:
        — this
           paw of steel
joined seas,
      prairies and deserts,
from here,
      Europe
          rushed to the West,
scattering
      to the wind
          Indian feathers.
This rib here
      reminds us
          of a machine —
imagine,
      enough hands, enough grip
while standing,
      with one steel leg
          in Manhattan
to drag
      toward yourself
          Brooklyn by the lip!

CONTINUED ON PAGE 37

34

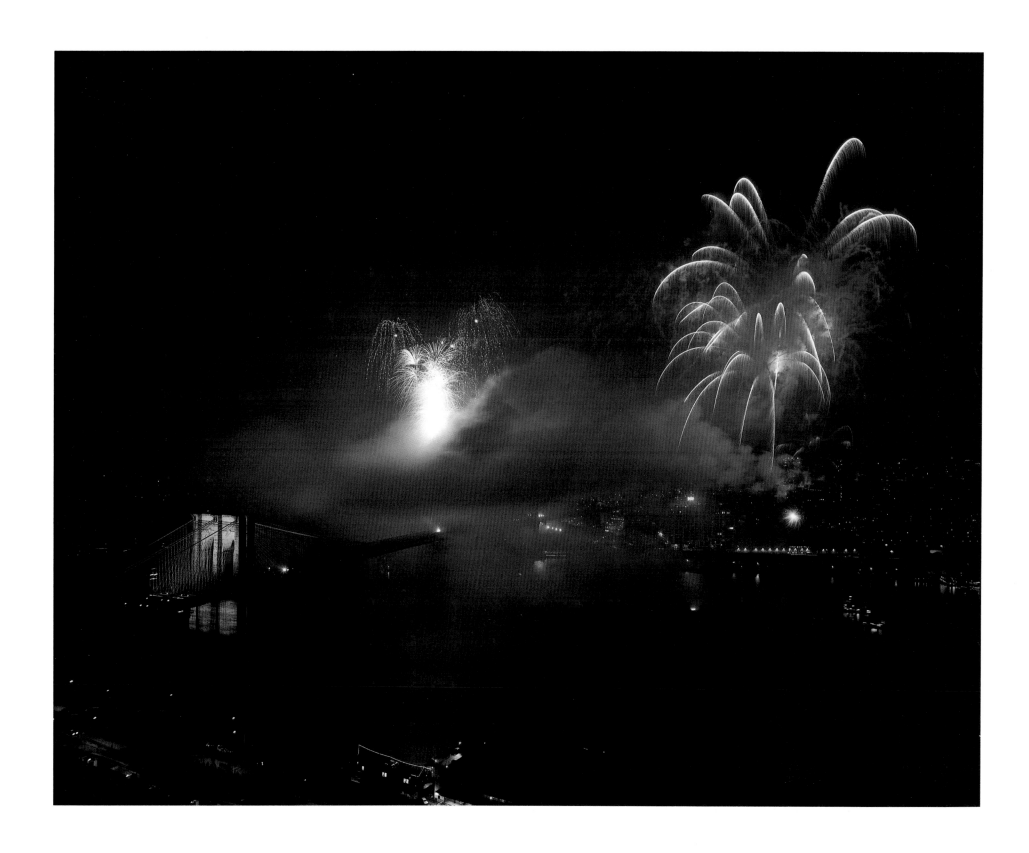

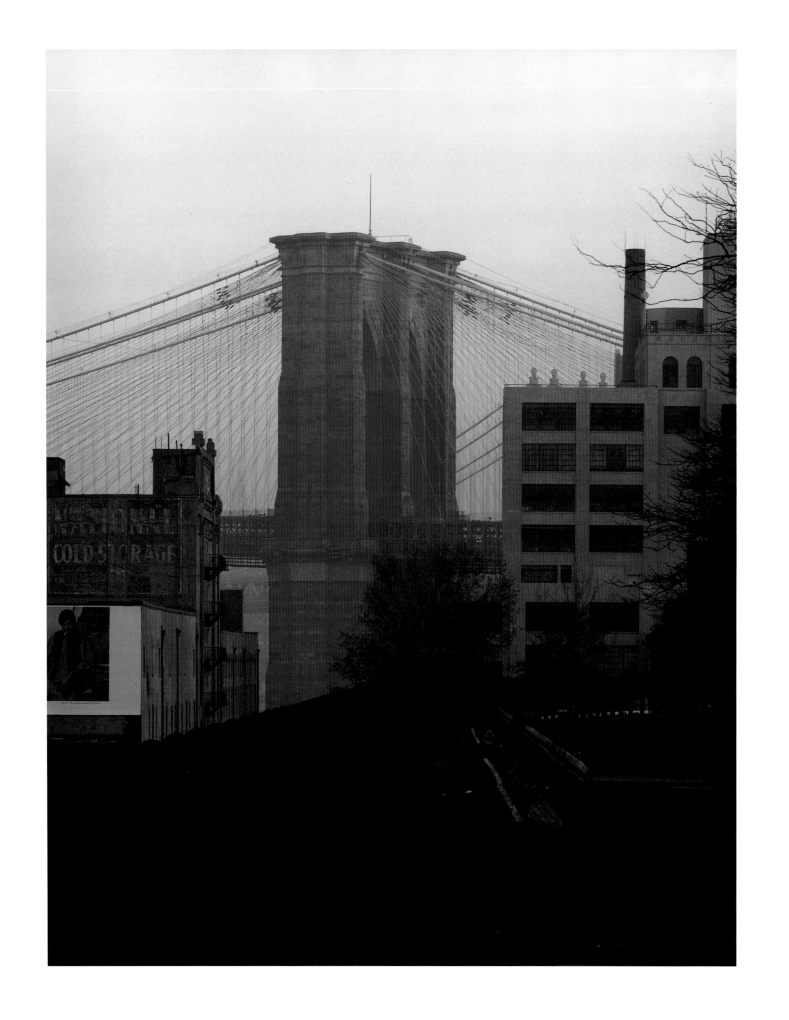

# EAST PIER OF THE BROOKLYN BRIDGE
# AND THE BROOKLYN HEIGHTS PROMENADE
## 1984

By the wires
              of electric yarn
I know this
          is
              the Post-Steam Era.
Here people
          already
                  yelled on the radio,
here people
          already
                  flew by air.
For some
          here was life
                      carefree,
                              unalloyed.
For others
          a prolonged
                  howl of hunger.
From here
          the unemployed
jumped headfirst
                  into
                      the Hudson.
And finally
          with clinging stars
                          along the strings of cables
my dream comes back
                  without any trouble
and I see —
          here
                  stood Mayakovsky,
here he stood
          putting
                  syllable to syllable.
I look,
      as an eskimo looks at a train,
I dig into you,
              like a tick into an ear.
Brooklyn Bridge.
Yes,
      you've got something here.

VLADIMIR MAYAKOVSKY
"Brooklyn Bridge," 1925

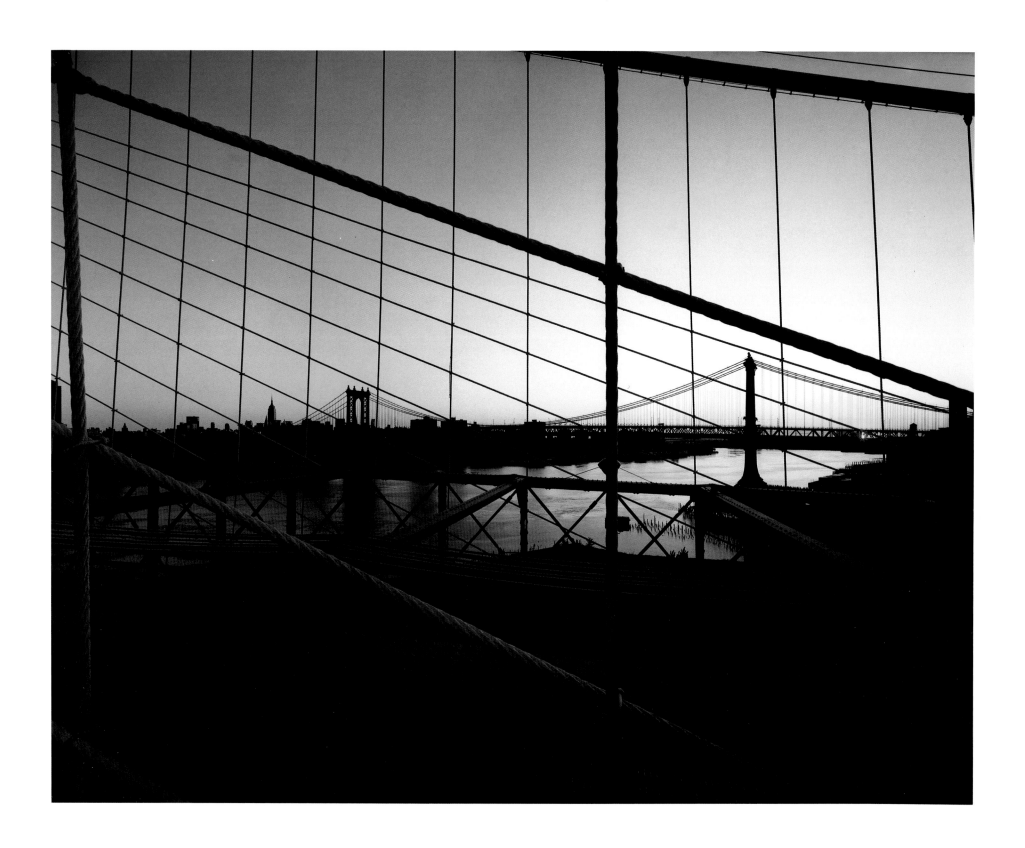

# 14
# THE MANHATTAN BRIDGE THROUGH THE BROOKLYN BRIDGE CABLES
## 1981

*Out of the cleansing night of stars and tides,*
*Building itself anew in the slow dawn,*
*The long sea-city rises: night is gone,*
*Day is not yet; still merciful, she hides*
*Her summoning brow, and still the night-car glides*
*Empty of faces; the night-watchmen yawn*
*One to the other, and shiver and pass on,*
*Nor yet a soul over the great bridge rides.*

*Frail as a gossamer, a thing of air,*
*A bow of shadow o'er the river flung,*
*Its sleepy masts and lonely lapping flood;*
*Who, seeing thus the bridge a-slumber there,*
*Would dream such softness, like a picture hung,*
*Is wrought of human thunder, iron and blood?*

RICHARD LE GALLIENNE
**"Brooklyn Bridge at Dawn"**

# UP THE EAST RIVER
## FROM WATERSIDE APARTMENTS
### 1981

The East River has had a long and eventful history that has reflected the changes in the life of the city since it was the Dutch settlement of New Amsterdam. The name came from the fact that in the part of the river of importance to the early colonists the current flows east and west. In 1656 a wall of planks was erected along the riverfront to protect the shore from the East River tides. Through the eighteenth and early half of the nineteenth centuries, the western shore was lined by great country estates. When, a hundred years ago, the American clipper ships were establishing speed records through the Seven Seas, many of the owning merchants, from their homes on Cherry Hill, could look from their windows at the gallant vessels at anchor in the East River.

Before the days of the bridges the East River meant far more to the city that it does today. A morning fog on the river, and work in half the business offices in New York was seriously delayed. The East River boats, the *Sylvan Glen, Sylvan Stream, Sylvan Shore, Sylvan Grove,* and *Sylvan Dell,* plying between Peck's Slip and Harlem, were, with the Broadway stages, the rapid transit of Little Old New York of the sixties. Jones' Woods, extending along the riverfront from what is now 66th to 75th Streets, was the site originally selected for Central Park.

ARTHUR BARTLETT MAURICE
*Magical City: Intimate Sketches of New York, 1935*

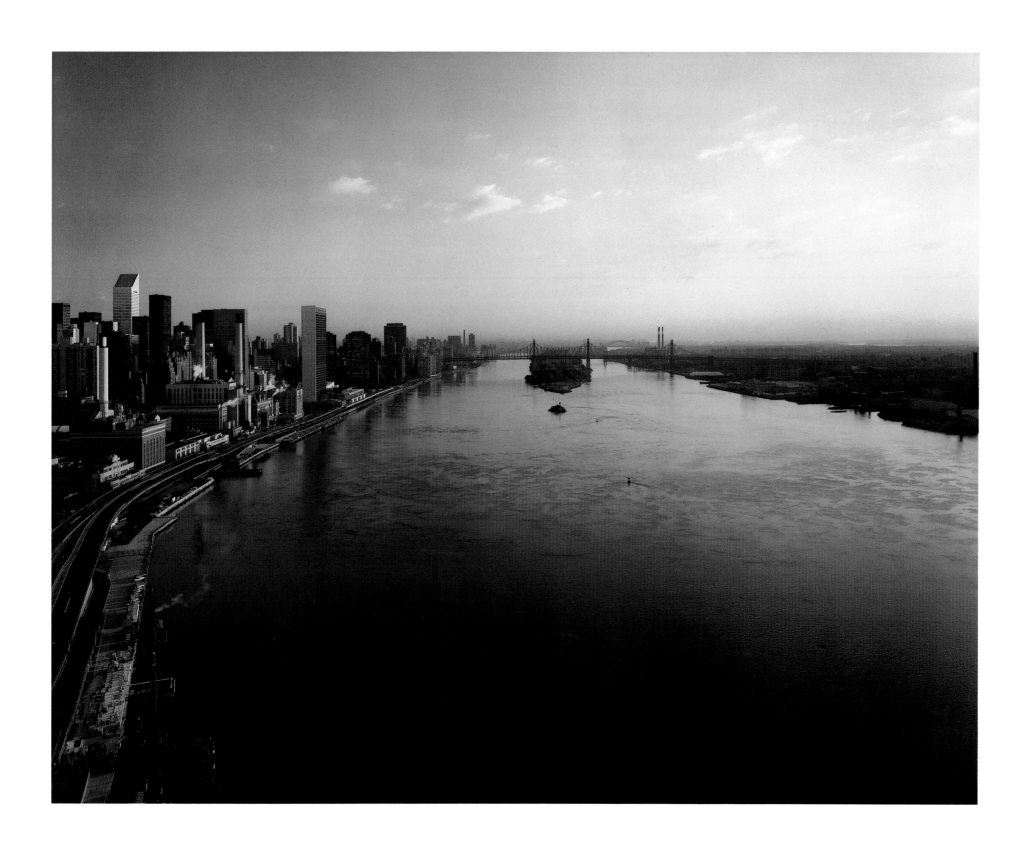

# 16

# MIDTOWN MANHATTAN

## FROM CITICORP AT COURT SQUARE, LONG ISLAND CITY

### 1990

Its specific beauty savours of the monstrous. The scale is epical. Too many buildings are glorified chimneys. But what a picture of titanic energy, of cyclopean ambition. Look over Manhattan from Washington Heights. The wilderness of the flat roofs in London; the winning profile of Paris; the fascination of Rome as viewed from Trinata dei Monti; of Buda from across the Danube at Pest—these are not more startlingly dramatic than New York, especially when the chambers of the west are filled with the tremendous opal of a dying day, or when the lyric moonrise paves a path of silver across the hospitable sea. . . .

JAMES HUNEKER
*Painted Veils,* 1920

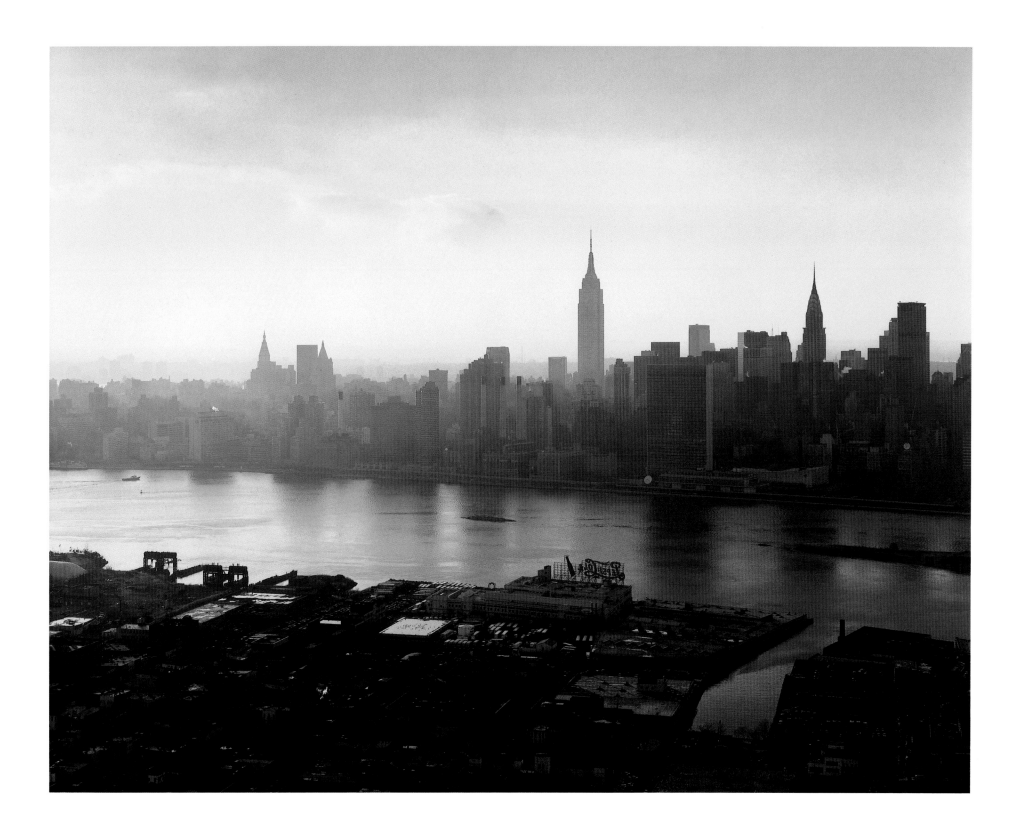

# THE 59TH STREET BRIDGE
## FROM ROOSEVELT ISLAND
### 1981

*A near horizon whose sharp jags*
    *Cut brutally into a sky*
*Of leaden heaviness, and crags*
*Of houses lift their masonry*
    *Ugly and foul, and chimneys lie*
*And snort, outlined against the gray*
    *Of lowhung cloud. I hear the sigh*
*The goaded city gives, not day*
*Nor night can ease her heart, her anguished labours stay.*

*Below, straight streets, monotonous,*
    *From north and south, from east and west,*
*Stretch glittering; and luminous*
    *Above, one tower tops the rest*
    *And holds aloft man's constant quest:*
*Time! Joyless emblem of the greed*
    *Of millions, robber of the best*
*Which earth can give, the vulgar creed*
*Has seared upon the night its flaming ruthless screed.*

*O Night! Whose soothing presence brings*
    *The quiet shining of the stars.*
*O Night! Whose cloak of darkness clings*
    *So intimately close that scars*
    *Are bid from our own eyes. Beggars*
*By day, our wealth is having night*
    *To burn our souls before altars*
*Dim and tree-shadowed, where the light*
*Is shed from a young moon, mysteriously bright.*

*Where art thou hiding, where thy peace?*
    *This is the hour, but thou are not.*
*Will waking tumult never cease?*
    *Hast thou thy votary forgot?*
    *Nature forsakes this man-begot*
*And festering wilderness, and now*
    *The long still hours are here, no jot*
*Of dear communing do I know;*
*Instead the glaring, man-filled city groans below!*

AMY LOWELL
"New York at Night"

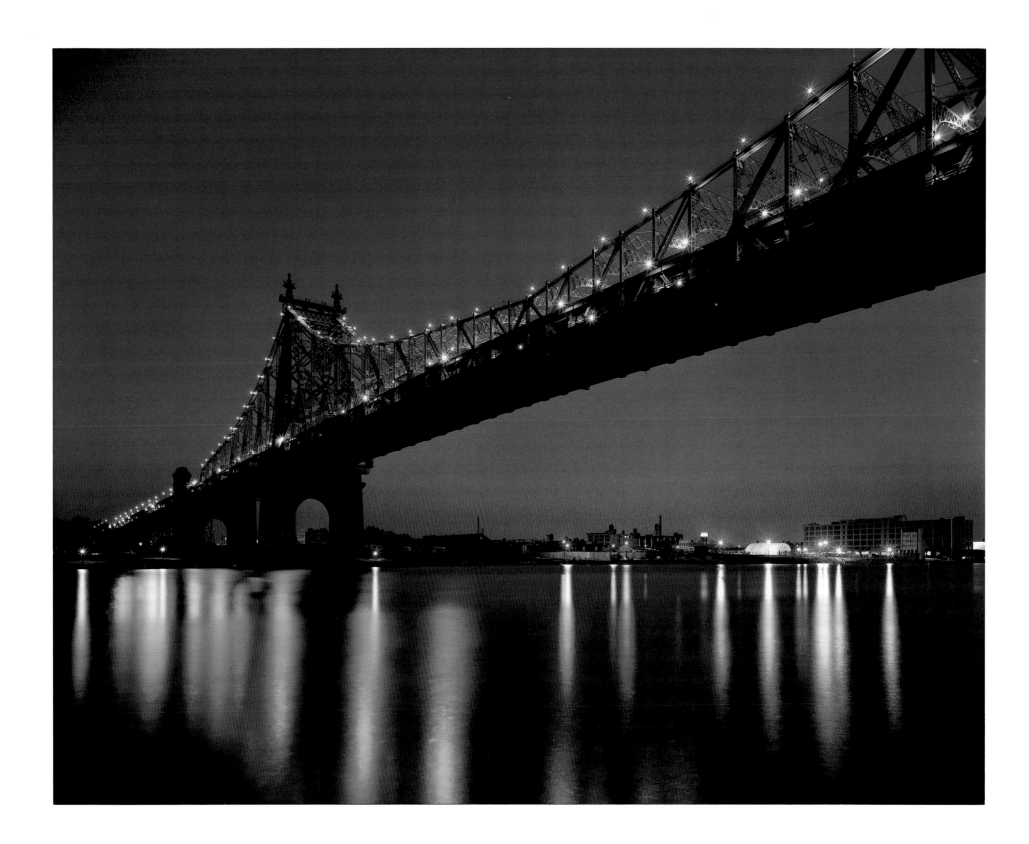

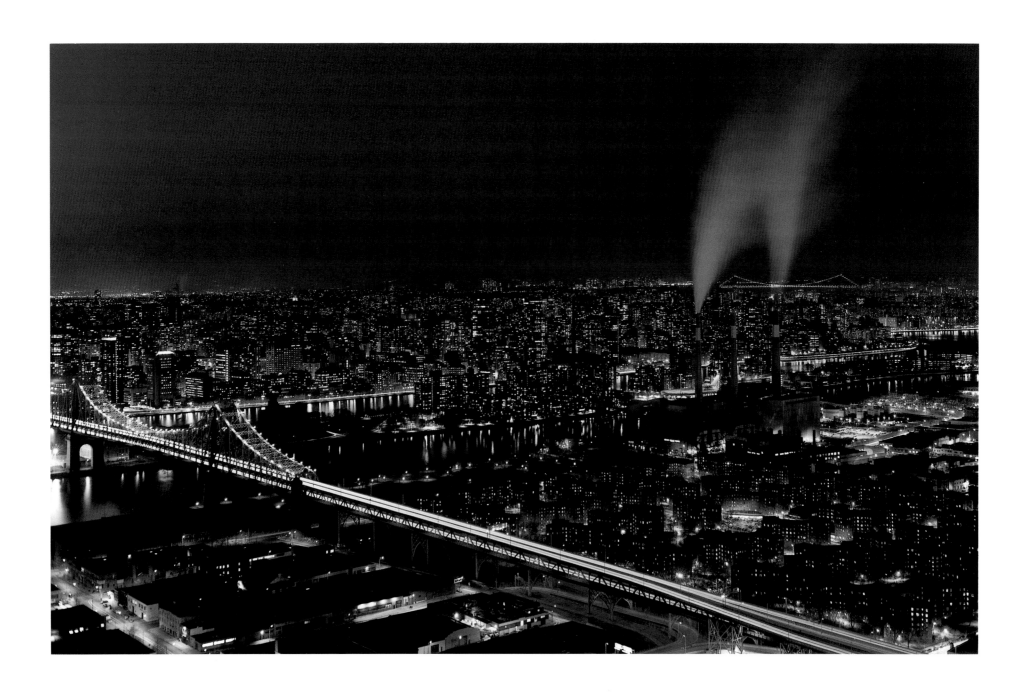

## 18

## THE 59TH STREET BRIDGE, "BIG ALLIS,"
## AND THE GEORGE WASHINGTON BRIDGE
## FROM CITICORP AT COURT SQUARE, LONG ISLAND CITY
## 1990

Evening is coming fast, and the tall frosted glasses in your hands make a thin but pleasant tinkling, and the great city is blazing there in your vision in its terrific frontal sweep and curtain of star-flung towers, now sown with the diamond pollen of a million lights, and the sun has set behind them, and the red light of fading day is painted upon the river—and you see the boats, the tugs, the barges passing, and the winglike swoop of bridges with exultant joy—and night has come, and there are ships there—there are ships—and a wild intolerable longing in you that you cannot utter.

When you go back into the room again, you feel very far away from Brooklyn, where you live, and everything you felt about the city as a child, before you ever saw or knew it, now seems not only possible, but about to happen.

The great vision of the city is burning in your heart in all its enchanted colors just as it did when you were twelve years old and thought about it. You think that same glorious happiness of fortune, fame, and triumph will be yours at any minute, that you are about to take your place among great men and lovely women in a life more fortunate and happy than any you have ever known—that it is all here, somehow, waiting for you and only an inch away if you will touch it, only a word away if you will speak it, only a wall, a door, a stride from you if you only knew where you may enter.

THOMAS WOLFE
"No Door," 1933

19

# THE EAST RIVER AT DAWN
## FROM THE WILLIAMSBURG BRIDGE
### 1989

Any sunrise on a clear day produces a dazzling effect along that Manhattan skyline, mostly from a variety of the despised new buildings, whose glass and burnished metals flash and glow as though aflame with molten heat; and when evening comes, the setting sun produces a second such display, best enjoyed by someone coming up the harbor or standing on the New Jersey side. With darkness, the skyline becomes entrancing in the manner of an illuminated Christmas tree, twinkling as thousands of lights are switched on. And it is a fact that, whatever time it may be between sunset and dawn that you look at those skyscrapers, all are partially lit, on different floors at different hours, each band of illumination signaling the nocturnal progress of the cleaners as they work their ways methodically up or down.

GEOFFREY MOORHOUSE
*Imperial City: New York,* 1988

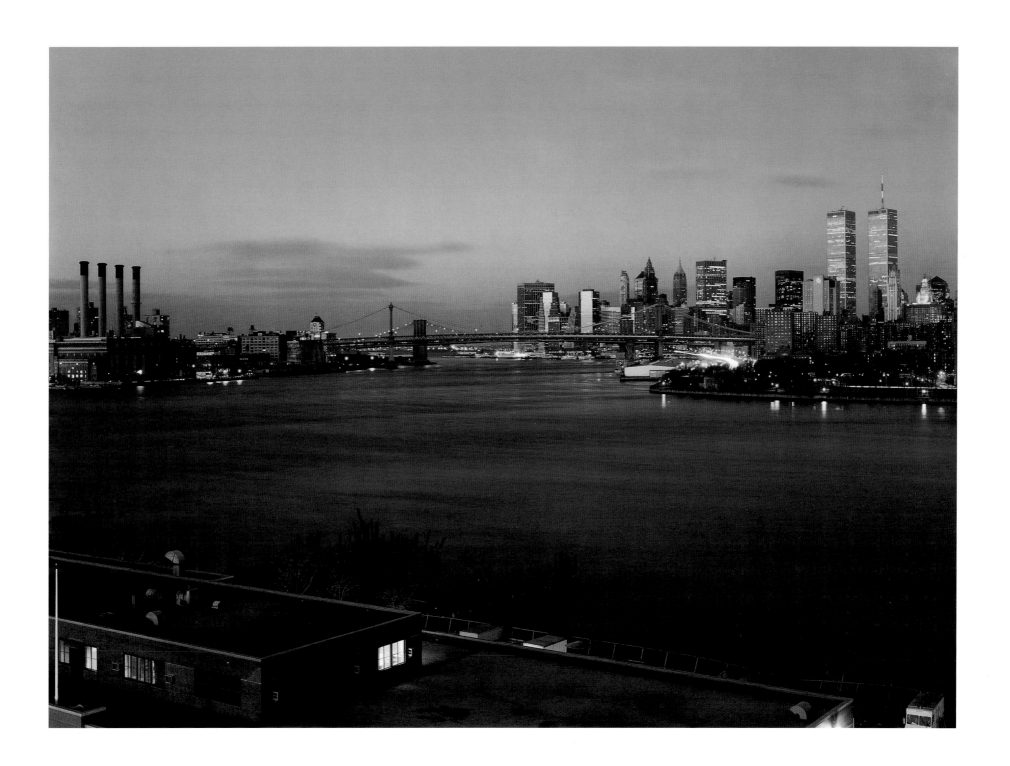

# 20
# THE UNITED NATIONS AND MIDTOWN SOUTH
## 1989

Here I was in New York, city of prose and fantasy, of capitalist automatism, its streets a triumph of cubism; its moral philosophy that of the dollar. New York impressed me tremendously because, more than any other city in the world, it is the fullest expression of our modern age.

LEON TROTSKY
*Novy mir,* 1917

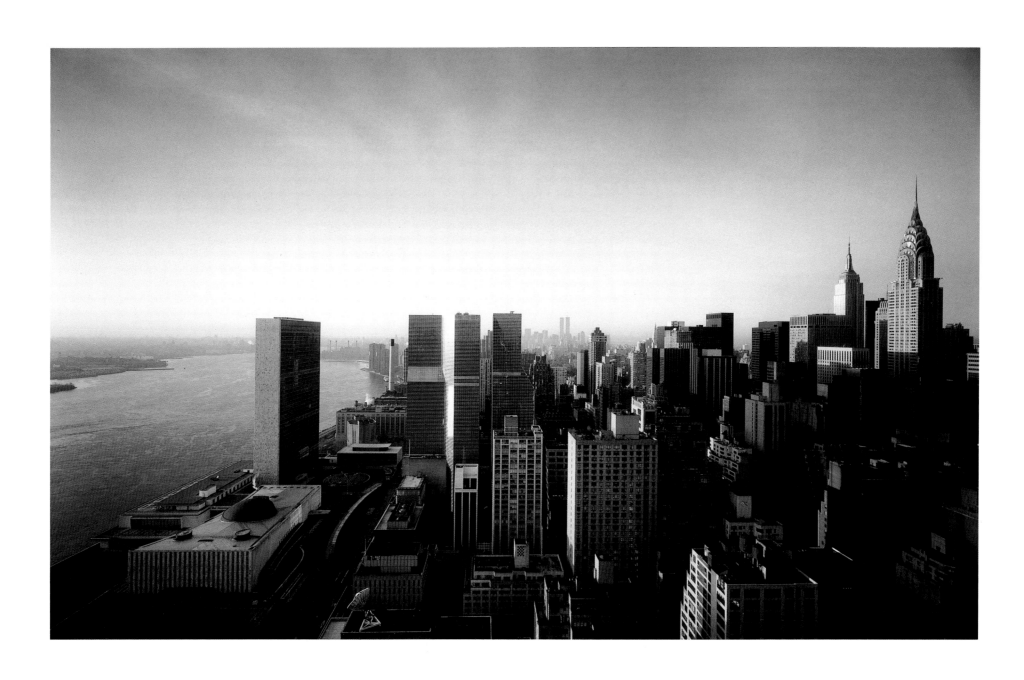

# 21

# MADISON SQUARE PARK AND THE METROPOLITAN LIFE BUILDING

## 1984

The seven-hundred-foot Metropolitan Life Insurance Company tower on the east side of Madison Square, a variation on the campanile in St. Mark's Square in Venice, was built in 1909 and designed by Napoleon LeBrun. Once the world's tallest building (a title it lost in 1913 to the Woolworth Building), it has always been one of the most pleasing eccentricities on the Manhattan skyline, with one of the largest four-face clocks in the world.

The lighting was designed by Al Piotrovsky, the Metropolitan's own electrician, and it is quite sensitive to the architecture—like the best lighting designs, it enhances rather than overshadows the building's basic architectural features. The thirty-fifth to forty-ninth floors of the tower are lighted in white, and the golden roof at the pinnacle is illuminated in sodium vapor lights to enhance the color. The tower can be seen well from midtown and lower Manhattan, and from close by on Madison Square.

PAUL GOLDBERGER
"Best Views of the New City of Lights," 1985

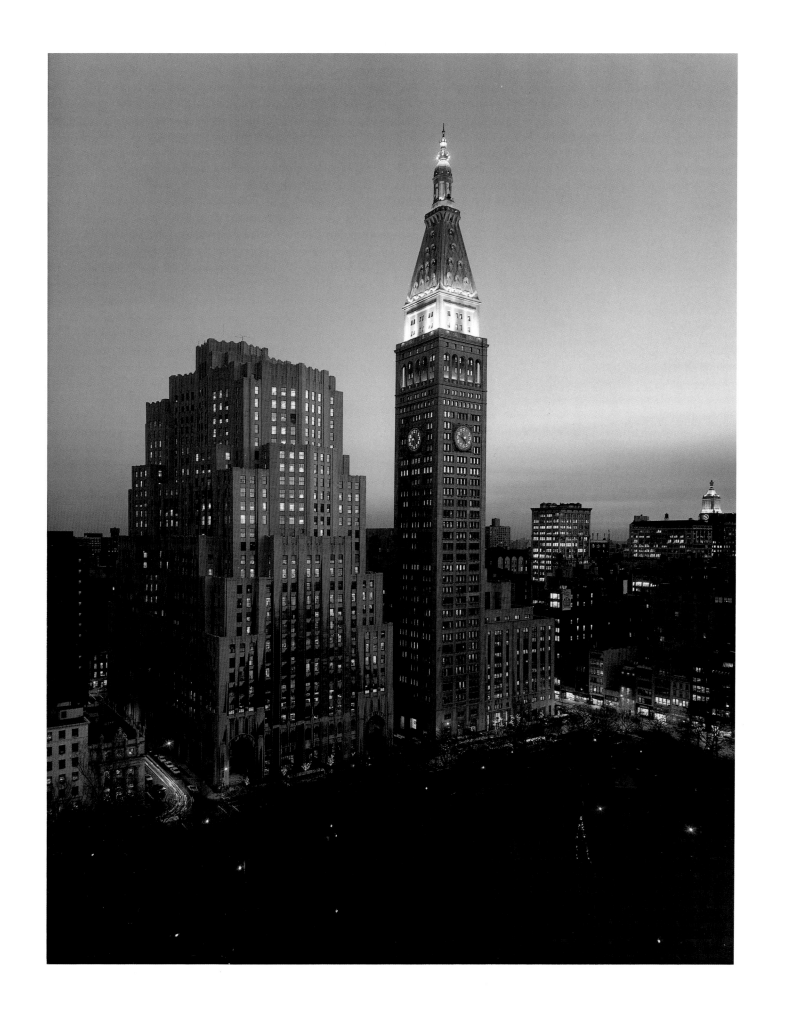

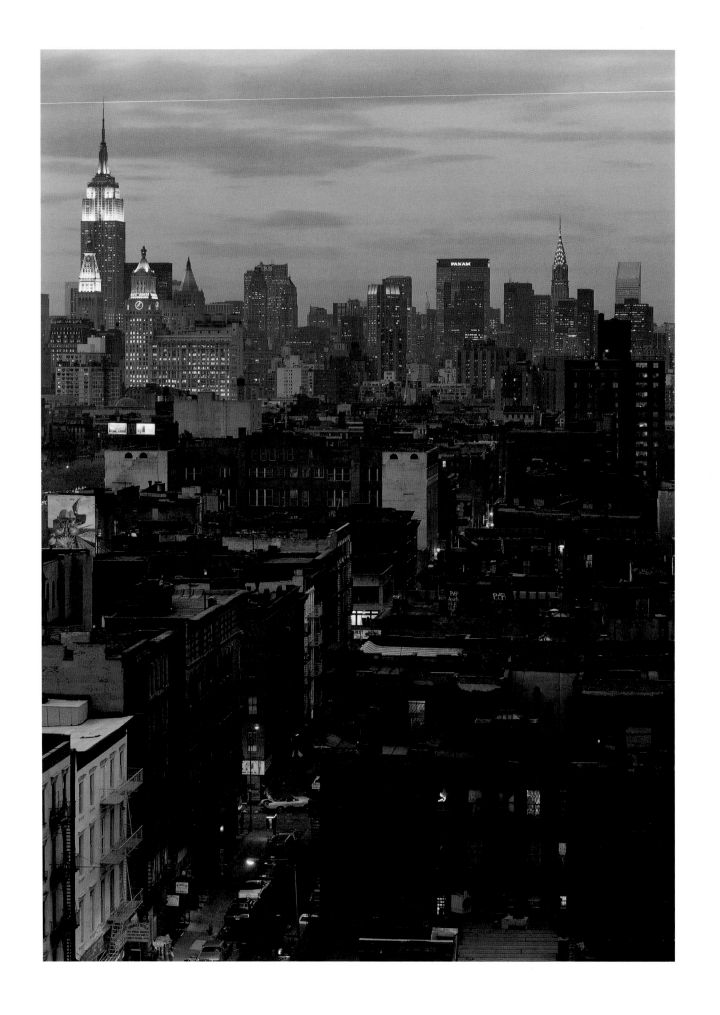

# 22

# VIEW NORTH FROM THE LOWER EAST SIDE

## 1982

Round the corner from the Chinese teashop long stood the Bowery eating place where once a penniless lad named Irving Berlin waited on table and picked out tunes on the piano for a living. Every guide included the spot in his itinerary before the building was torn down. The night I made the trip, our informant even declared that it was on that very battered piano that Berlin had composed "White Christmas."

One evening Irving Berlin himself decided to visit his old haunt. In a nostalgic glow, he seated himself at the piano and began to hum, "Oh, How I Hate to Get Up in the Morning." In the middle of the rendition, a busload of sightseers shuffled in, and their gravel-voiced guide began his spiel.

"Yes, sir, folks," he declared, "this is the very place the great Oiving Boilin began his career—singing songs on that same pianner you see standing in the corner. As a matter of fact, the song that Bowery bum is playin' this minute happens to be one of Boilin's own songs!"

The guide then walked over to the piano and dropped a heavy hand on Berlin's shoulder.

"Fella," he announced, "if Oiving Boilin could hear the way you're moiderin' one of his greatest songs, he'd toin over in his grave!"

BENNETT CERF
"The Cerf-board—The Bowery," 1952

# VIEW NORTH FROM FOLEY SQUARE

## 1988

New York's history is what happened tomorrow. The Dutch planned it that way. They built a replica of Amsterdam at the foot of Manhattan, a phantom city with windmills and all. And the practical Dutch pretended they were still at home. They weren't *colonists;* they didn't want a New World. They closed their eyes and had their "fabricated motherland." It's no wonder the English took New Amsterdam without a shot. The Dutch were crazy. They thought these gutters and gardens were in some old town. Why should they fight the British for a territory that was as familiar as their own finger? They were Dutch. This had to be Amsterdam. And the English could go to hell.

The Britishers succumbed to that vision. New York remained "new" Amsterdam. The English presence in New York was so illusory because it never took hold. That's why I'd suffered amnesia about the British. They were ruled by Peter Stuyvesant's ghost. And after the redcoats were gone, we still had a Dutch colony, even with the Declaration of Independence. New York was practical and insane. It continued to trade like the Dutch and build on that phantom city. It decided to grow along a grid, ignoring bumps, ditches, and heights, and the particular bend of its rivers. It would be a phantom grid of 2028 blocks, where anything that was built upon them could be removed at will. So we have the Empire State Building dug into the old cradle of the Waldorf-Astoria. And the Waldorf is shoved onto another grid. We have a Madison Square Garden on Madison Square and then the Garden starts to float, like a gondola on the grid. It reappears uptown, caters to circuses and rodeos, the Rangers and the Knicks, becomes a parking lot, and the Garden is born again over the new Penn Station. It's an ugly glass tank, but who cares? Nothing is sacred except the grid. And the grid doesn't allow for memory and remorse. It's part of a phantom town built onto a Dutch vision of Amsterdam in America, which happens to be called New York.

JEROME CHARYN
*Metropolis,* 1986

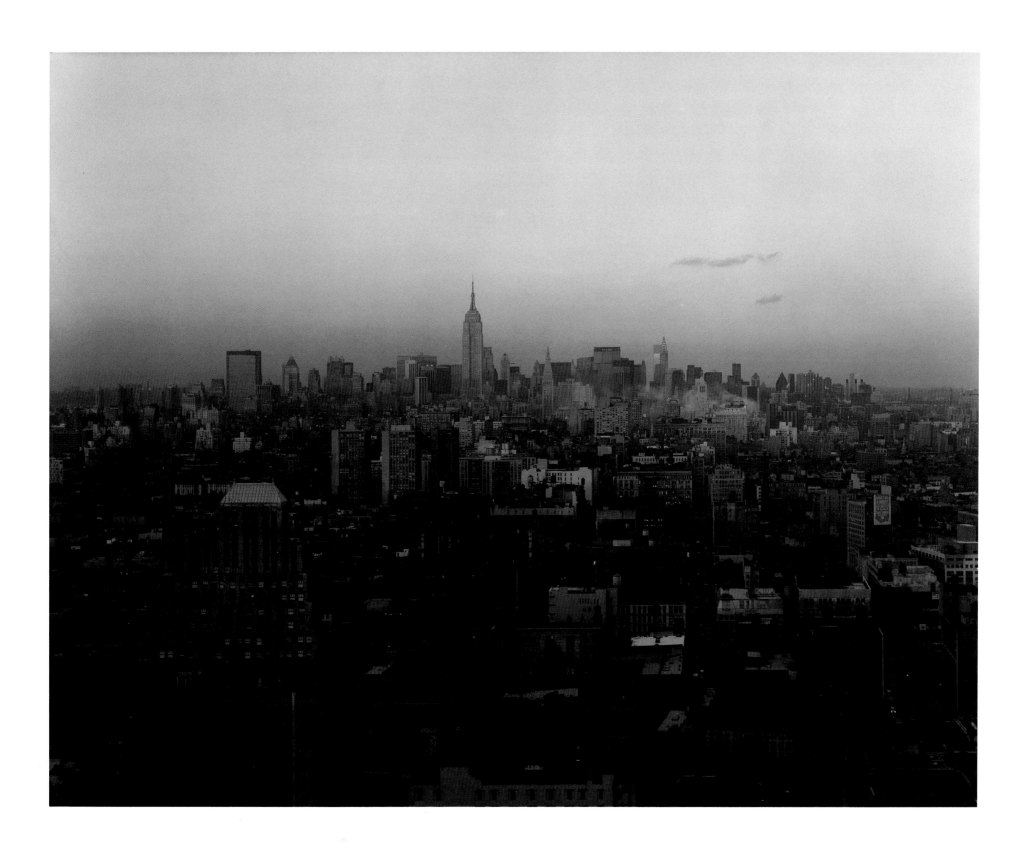

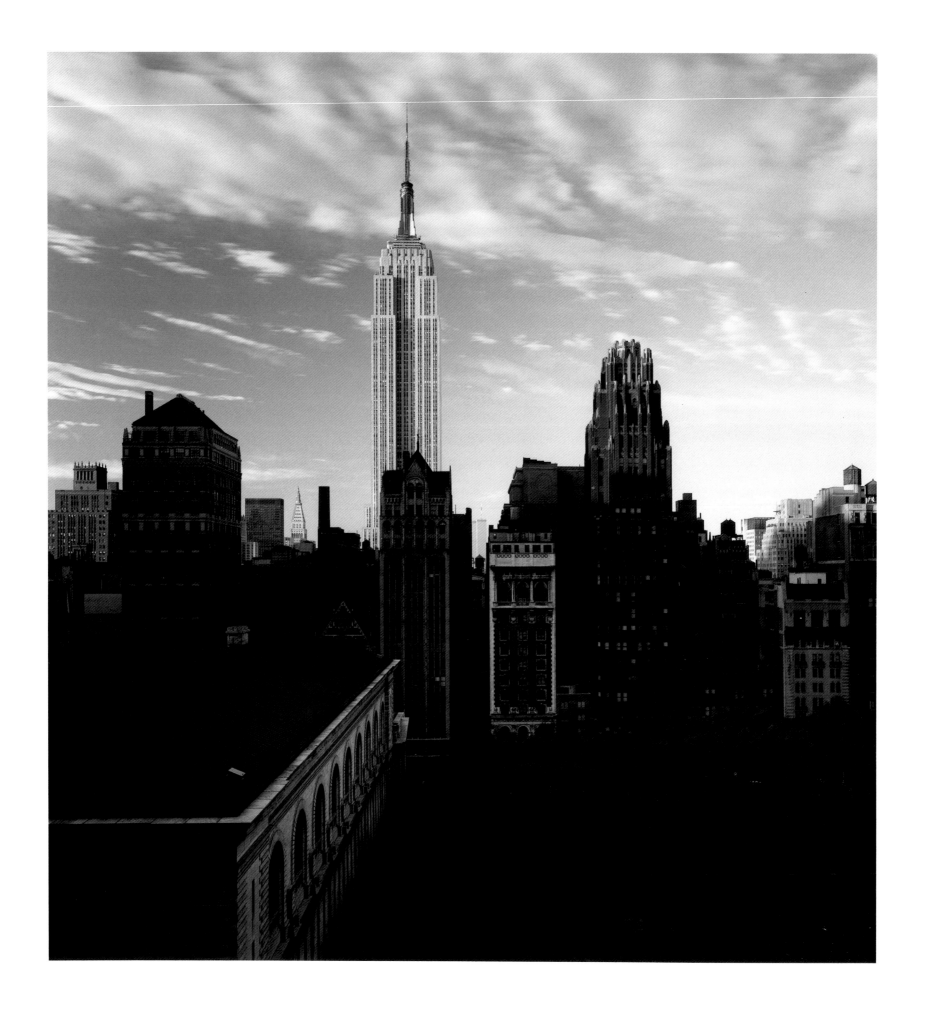

# THE AMERICAN STANDARD BUILDING
# AND THE EMPIRE STATE BUILDING
# ACROSS BRYANT PARK

## 1981

The classic example of the cold, efficient city editor is, of course, the late Charles E. Chapin, who died in 1930, in Sing Sing Prison, where he had been sent after he had shot and killed his wife, Nellie Beebe Chapin, as she lay asleep in their hotel room in New York. Today, men who develop traits and methods similar to his are said to be marked with the "Chapin stigmata."

He was rather generally hated in the office of the *Evening World,* which he ruled with more power than most city editors have, but his professional ability was respected, and with good reason. The oldest story of him is how Irvin S. Cobb, then on the staff, heard that Chapin was ill and looked up from his typewriter to remark, "I trust it's nothing trivial."

\* \* \* \* \*

Chapin as city editor fired 108 men. . . .

He had no patience with amateurs, incompetents or bunglers. He knew his job and expected the men to know theirs. He could spot a four-flusher at a great distance and he prided himself on the variety of ways in which he fired men. Once a reporter was late telephoning a story. Chapin barked at him: "Your name is Smith, is it? You say you work for the *Evening World,* do you? You're a liar. Smith stopped working for the *Evening World* an hour ago."

A reporter who was late for work told Chapin a complicated story of having scalded his foot in the bathtub. A few days later Chapin fired the reporter, explaining, "I would have fired you earlier but I wanted to see how long you could keep on faking that limp." A young man asked Chapin "what to do next" while he was covering a big fire. "Go pick the hottest place and jump into it," advised the tyrant. Sometimes, however, he fired people without meaning to. The old-timers could tell when a "firing" was real and paid no attention to the other kind. One younger man took Chapin at his word when the great man told him he was fired, and did not report at the office next day. He received a telegraph from Chapin, saying, "If you are not back at work by Thursday morning, you are fired."

It was difficult to fool the old man. Once the Criminal Courts reporter missed a ferry from Staten Island and telephoned to the office from the ferry house at 9 A.M., reporting that he was on the job at the courthouse. "Cover the flood," ordered Chapin. "What flood?" "There must be a terrible flood at the Criminal Courts building," said Chapin. "I can hear the boats whistling."

Chapin was a good but cantankerous judge of writing. He once fired a man for using the word "questionnaire," which at that time had not been admitted to the dictionary. On another occasion, a reporter, writing of the finding of a body floating in the East River, referred to the "melancholy waters."

"Pretty good phrase, that," said Chapin.

He was overheard; thereafter, for days, the Harlem River, the Gowanus Canal and Spuyten Duyvil all developed "melancholy waters." Chapin issued a warning that the next man who used the phrase would be fired. A young reporter, Dwight Perrin, who later became city editor of the *Tribune* and after that assistant managing editor of the St. Louis *Post-Dispatch,* had not heard of the warning, and the next day his first story was that of a suicide whose body had been picked up in the Hudson. Perrin started his article, "The melancholy waters of the Hudson—"

Chapin was furious.

"You're fired," he said. " 'Melancholy waters! Now, look here, in all sense, how could the waters of the Hudson be melancholy?"

"Perhaps," suggested Perrin, "it was because they had just gone past Yonkers."

"Not bad," said Chapin "You're hired."

STANLEY WALKER
"Chapin of the *World,*" 1934

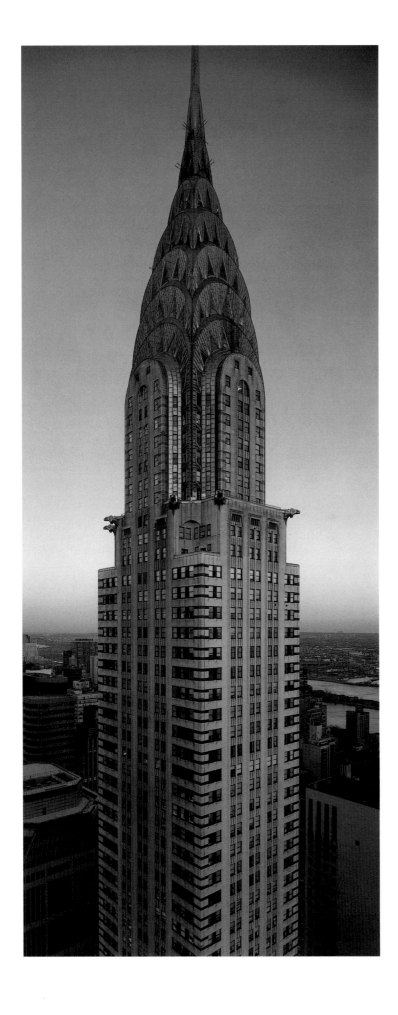

## 25
# THE CHRYSLER BUILDING
## FROM THE CHANNIN BUILDING
### 1989

Whenever that melancholy hits, the rub of New York, the realization that we're a town of such cruelties, with the relentless rise to fortune as our biggest theme song (we're all Mafia men), the grasping, the clutching, the hundred little dances we do to keep alive, from eating Stresstabs to showering and shaving, shrugging off the ghosts of sleep, the dread of a girlfriend gone . . . I put on my shoes and walk to the Chrysler Building. The whimsy of that steel top, a witch's hood with a host of triangular eyes, is enough to shake the sadness out of me. It's a reminder that New York once had an element of pure play, the belief in its own modernity. The building is slightly mad, with hubcaps in the walls, gargoyles borrowed from old Chrysler machines, and futuristic cars trapped in a design of brick. Chrysler has an innocence, a total trust in the passion and good of industry, that's all but gone. Its entrance looms like a church celebrating the dream of the automobile, and its own breathless future, as Walter Chrysler saw it.

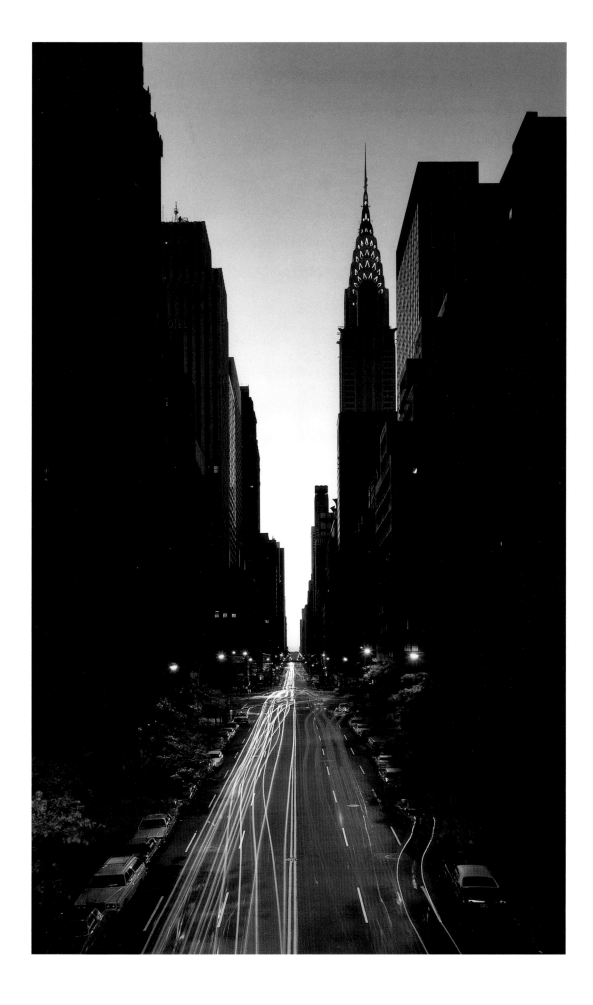

## 26

# THE CHRYSLER BUILDING
# AND EAST 42ND STREET

## 1981

But I didn't put my socks on for an automobile show. The lobby of the Chrysler Building is one of the great hidden spectacles of New York. It's not a tourist attraction, a hangout, a home for shopping-bag ladies. It's a spa for melancholics like me. You enter into the softest light you could imagine, as if bulbs had suddenly become quiet worms under glass and you'd gone into a land of burnished red marble that bore no resemblance to the streets. It's like one of Roxy's movie palaces: a dreamscape with elevators, a clock, and solid chrome. The clock is set in a dark wall, and its illumination is almost the drama of time itself—as if the dials were inventing each moment, and Chrysler caught you, held you in its sway. Nothing jars. Nothing hurts your system. Elbows never bump along those walls. You've fallen into the design and you're cradled there, crazy as it seems.

JEROME CHARYN
*Metropolis,* 1986

# 27

# 57TH STREET LOOKING EAST

# 1981

Where should I go, on this, my first evening? . . . a first night in New York is as a first night in no other city. In Paris one can lie in a chaise-longue and watch the street-lamps glowing through the chestnut trees; in Venice one can sit at a window and listen to the water lapping against the walls; in London one not only can but *must* go straight to bed, as there is nothing else to do. . . . Not so in New York. Here the city orders you to come out and greet it, in a thousand strident voices, with a million golden, beckoning fingers. . . .

I decided to drift at random; . . . at every twist and turn there were marvels. . . . black torrents of sleek cars . . . charging throngs of women who all appeared to be wearing a compulsory uniform of mink. But it is the beauty rather than the opulence of New York that catches the traveller by the throat as he turns from 60th Street into Fifth Avenue. For now the dusk was trembling into night; it was the city's *heure exquise,* and ahead stretched the bewil-

dering façade of the buildings that run west of the Park. The geometrical masses of the Plaza Hotel had been transformed into a frail filigree of light and shade, linked by chains of diamonds to distant towers and temples, as tall flowers might be linked by spiders' webs in a garden after rain.

I turned down the Avenue. . . . More than ever before, as the shop windows filed past in a glittering parade, there was the sense of New York as a great international city to which all the ends of the world had come. London used to be like that, but somehow one had forgotten it, so long had it been since the Hispanos and the Isottas had glided down Piccadilly, so many aeons since the tropical fruits had glowed in the Bond Street windows. Coming from that sort of London to America, in the old days, New York had seemed just—American; not typical of the continent maybe, but American first and foremost. Now it was the centre of the world.

BEVERLEY NICHOLS
*Uncle Samson,* 1950

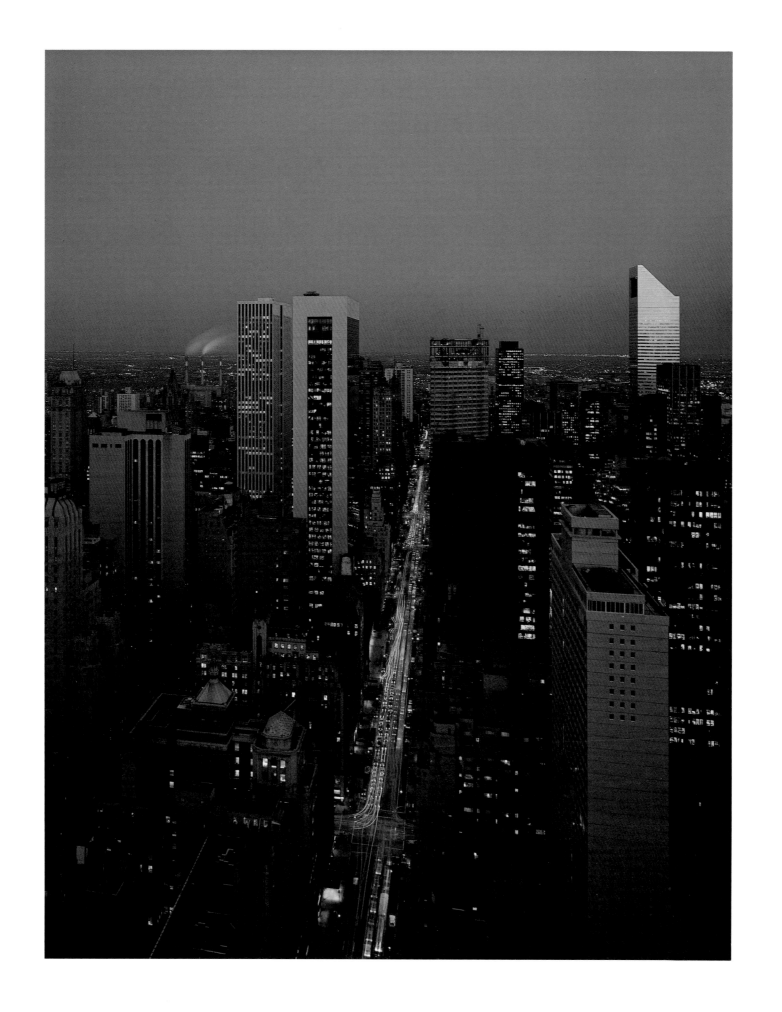

# 28

# PARK AVENUE

## FROM LEVER HOUSE

## 1985

The word *home* takes on a coloring in Manhattan, a particular shape, a philosophical density that it has nowhere else on the planet. Home is where landlords and tenants engage in guerrilla war, and the City becomes a constant referee. We don't have oil. We don't have diamonds under the street. But we do have land. And people have been known to kill for it, lie, cheat, and take their own fathers to court. "Real estate may be New York's most valuable commodity," says the *New York Times,* as if it had just discovered America. Real estate is what the hell New York has always been about. Until the nineteenth century, a man had no recognizable worth without a piece of real estate. He couldn't vote. He couldn't say boo. He was considered an orphan, some homeless thing who happened to be around. New York's three "perpetual children" were women, slaves, and landless men.

JEROME CHARYN
*Metropolis,* 1986

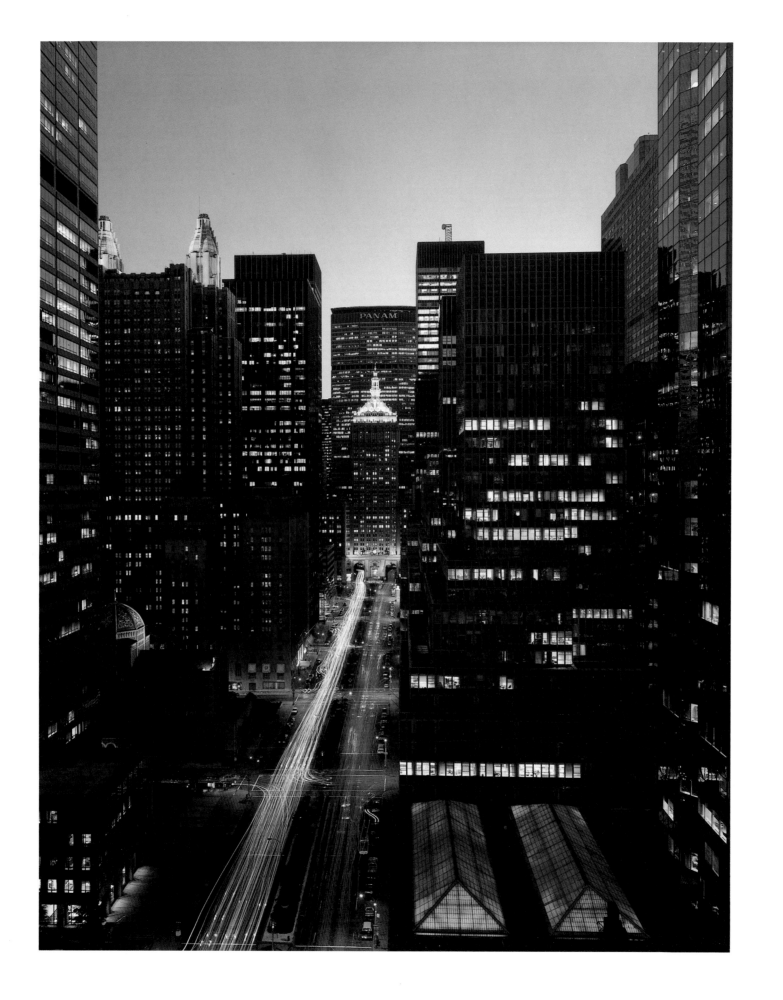

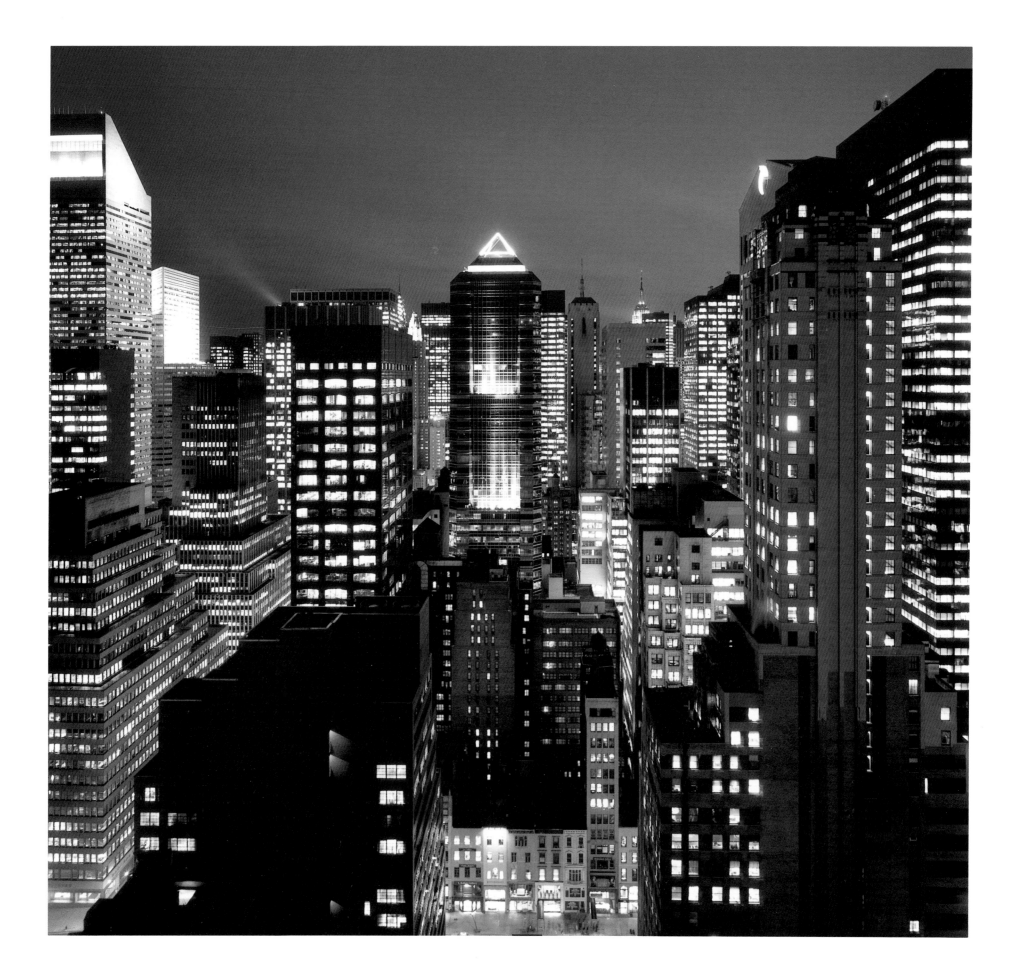

# 29

# MIDTOWN WITH 57TH STREET
# IN THE FOREGROUND

## 1987

Beneath the immaculate office on the fifty-sixth floor the vast nocturnal festival of New York spreads out. No one can imagine it who has not seen it. It is a titanic mineral display, a prismatic stratification shot through with an infinite number of lights, from top to bottom, in depth, in a violent silhouette like a fever chart beside a sick bed. A diamond, incalculable diamonds.

The great masters of economic destiny are up there, like eagles, in the silence of their eminences. Seated in their chairs, framed by two plate glass windows which fuse their rooms with the surrounding space, they appear to us made out of the substance of this event which is as strong and violent as a cosmic mutation: New York standing up above Manhattan is like a rose-colored stone in the blue of a maritime sky; New York at night is like a limitless cluster of jewels.

LE CORBUSIER
*When the Cathedrals Were White, 1947*

# THE ELDORADO ACROSS CENTRAL PARK
## 1981

Central Park was designed in 1858 by Frederick Law Olmsted and Calvert Vaux; it is wholly man-made. What seems nature's gift is the result of work and dreams. "Every foot of the park's surface, every tree and bush, as well as every arch, roadway and walk," wrote Olmsted, "has been fixed where it is with a *purpose*." In its design it represents a high degree of sophistication, the culmination of England's picturesque landscape tradition molded to American vision. If the Lower or Southern Section presents the pastoral of this tradition, the Upper or Northern Section presents the strictly picturesque or natural. Together they form a grand design, a closely knit unit where lawn, glade, water and wilderness weave in and out to push back the turbulent metropolis. Central Park is, in fact, a giant public garden, a supreme American work of art.

. . . The poet William Cullen Bryant made one of the first demands for a park. "Commerce is devouring inch by inch the coast of the island," he warned in 1844, "and if we would rescue any part of it for health and recreation it must be done now. . . . All large cities have their extensive public grounds and gardens, Madrid and Mexico [City] their Alamedas, London its Regent's Park, Paris its Champs Elysées and Vienna its Prater." A year later he wrote in a letter that

*the population of your city, increasing with such prodigious rapidity, your sultry summers, and corrupt atmosphere generated in hot and crowded streets, make it a cause of regret that in laying out New York, no preparation was made, while it was yet practicable, for a range of parks and public gardens along the central part of the island or elsewhere, to remain perpetually for the refreshment and recreation of the citizens during the torrid heats of the warm season. There are yet unoccupied lands on the island which might, I suppose, be procured for the purpose, and which, on account of their rocky and uneven surfaces, might be laid out into surpassingly beautiful pleasure-grounds, but, while we are discussing the subject, the advancing population of the city is sweeping over them and covering them from our reach.*

A second and equally powerful voice raised for a park was that of the landscape architect, Andrew Jackson Downing. "A large public park . . ." he wrote in 1849 in his magazine, *The Horticulturist,* "would not only *pay* in money, but largely civilize and refine the national character, foster the love of rural beauty, and increase the knowledge of, and taste for, rare and beautiful trees and plants. . . . The true policy of republics is to foster the taste for great public libraries, parks and gardens which *all* may enjoy."

. . . The demands of the two men, voiced on these shores for the first time, reflected an American current of a larger stream, the Romantic Movement, which saw in nature a refuge from the spreading Industrial Revolution. Even before Bryant and Downing spoke up, James Fenimore Cooper was writing some of the finest passages on the native wilderness. The descendants of men who had looked on nature as an enemy were turning away from the scarred landscape. While mourning what had been destroyed by greed and haste, they were discovering that American nature could be a vast garden.

. . . It was only with Andrew Jackson Downing, already mentioned as one of the chief proponents of a large park for the city, that the science and art of gardening were joined in one person. A citizen of Newburgh, he had begun to landscape estates along the Hudson when, in 1841, he wrote *A Treatise on the Theory and Practice of Landscape Gardening, Adapted to North America: With a View to the Improvement of Country Residences.* The book achieved tremendous popularity. "The *beau ideal*," he wrote, "in Landscape Gardening as a fine art appears to us to be embraced in the creation of scenery expressive of a peculiar kind of beauty, as the elegant or picturesque. . . ."

. . . Mostly due to the agitation of Downing and Bryant, creation of a large park became a political issue in New York by 1850. During the mayoralty campaign of that year both candidates came out for one, and in 1851, the winner, Mayor Ambrose C. Kingsland, asked the Common Council to take action. That worthy body recommended Jones Wood, 153½ acres bounded by Third Avenue and the East River from 66th to 75th streets. The State Legislature, where real power still resides in such matters, confirmed the choice. Downing, who had very definite ideas on what a park should be, at once protested the size and site in *The Horticulturist* of August, 1851:

Five hundred acres *is the smallest area that should be reserved for the future wants of such a city, now, while it may be obtained. Five hundred acres may*

CONTINUED ON PAGE 70

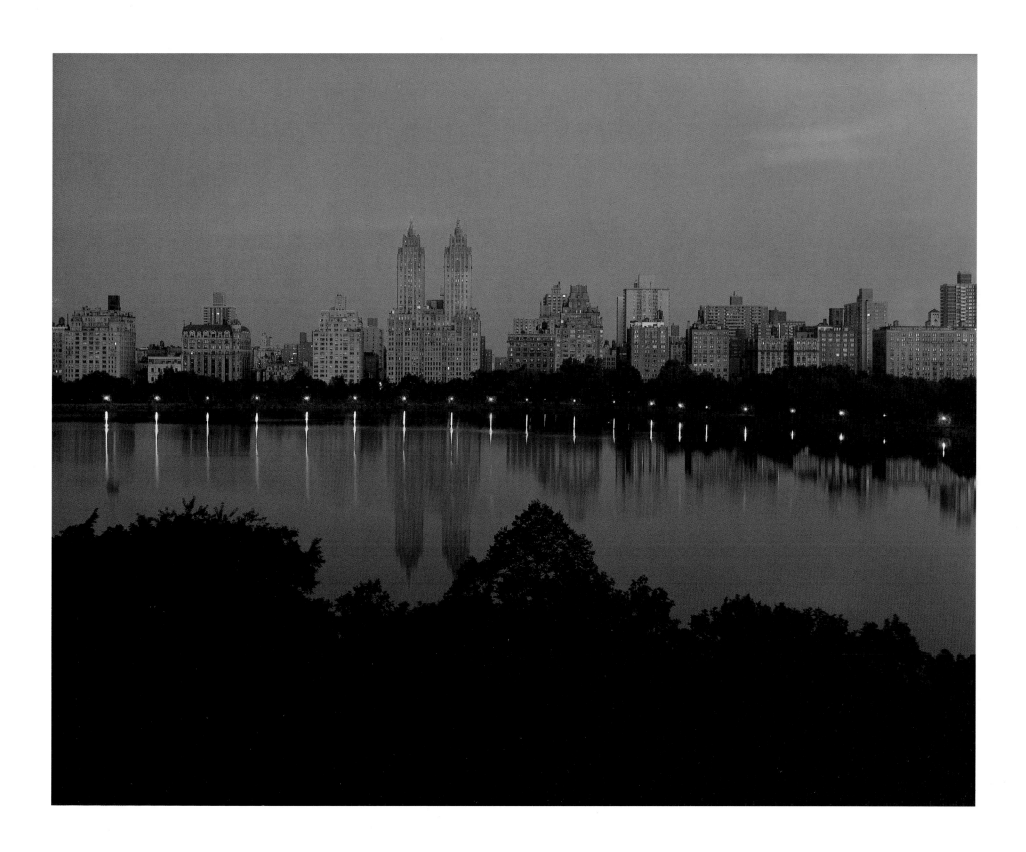

# CENTRAL PARK

## LOOKING NORTH FROM 57 TH STREET

### 1981

*be selected between 39th Street and the Harlem River, including a varied surface of land, a good deal of which is yet waste area, so that the whole may be purchased at something like a million of dollars. In that area there would be space enough to have broad reaches of park and pleasure-grounds, with a real feeling of the breadth and beauty of green fields, the perfume and freshness of nature. In its midst would be located the great distributing reservoirs of the Croton aqueduct, formed into lovely lakes of limpid water, covering many acres, and heightening the charm of the sylvan accessories by the finest natural contrast. In such a park, the citizens who would take excursions in carriages, or on horseback, could have the substantial delights of country roads and country scenery, and forget for a time the rattle of the pavements and the glare of brick walls. Pedestrians would find quiet and se-cluded walks when they wished to be solitary, and broad alleys filled with thousands of happy faces, when they would be gay. The thoughtful denizen of the town would go out there in the morning to hold converse with the whispering trees, and the wearied tradesmen in the evening, to enjoy an hour of happiness by mingling in the open spaces with "all the world."*

In other words, Central Park. A year after he wrote this, Downing, only thirty-seven, drowned in the Hudson, rescuing his mother-in-law in a gruesome steamboat disaster off Riverdale. Had he lived he would have designed the new park.

In 1853 the State Legislature authorized the city to buy the site from 59th to 106th streets between Fifth and Eighth avenues, some 624 acres. . . . By 1859 it was decided that the park should be enlarged to include the land from 106th to 110th streets. With its acquisition total acreage came to 843 acres.

. . . The land that became Olmsted's province must have been a discouraging sight, filled as it was with squatters' shacks, bone-boiling works, "swill-mills" and hog farms, offering a spectacle not too different from the one still to be seen in the Jersey meadows from turnpike and railroad. Interspersed among the swamps, creeks which were open sewers, and bramble-covered grounds were no less than three hundred hovels. Olmsted summed up the site as "a pestilential spot, where rank vegetation and miasmatic odors taint every breath of air."

. . . Although he was superintendent, Olmsted had no idea of extending the power of his office to designing a plan for the park; his job was to clear the ground. Even when the commission announced a competition for a park design in October, 1857, he gave no thought to competing until Calvert Vaux, an architect, suggested that they collaborate. Still Olmsted hesitated, thinking that Vielé, his superior, who had already prepared a plan for the park, might frown on the effort; only after Vielé offered no objection did Olmsted accept Vaux's invitation. The two men submitted their plan on April 1, 1858, under the signature "Greensward"; on April 28, Greensward was declared the best of the thirty-three competing plans.

. . . On his own and his neighbors' farms on Staten Island, Olmsted had undertaken some land-scaping, "as any fairly well-to-do, working farmer may. . . ." As to a specific interest in public parks, he was to write to Vaux with that serious and, perhaps, humorless tone that was so characteristic of the man:

*that this was something deeper than a whim you know, for you know that it existed essentially years before it attached itself to the Central Park as was shown by the fact that while others gravitated to pictures, architecture, Alps, libraries, high life and low life when travelling, I had gravitated to parks,— spent all my spare time in them, when living in London for instance, and this with no purpose whatever except a gratification which came from sources which the Superintendence of the Park would have made easy and cheap to me to say the least, every day of my life. What I wanted in London and in Paris and in Brussels and everywhere I went in Europe—what I wanted in New York in 1857, I want now and this from no regard for Art or fame or money.*

Unlike his collaborator, Calvert Vaux was a professional. Born in London in 1824, he was apprenticed while quite young to a leading archi-tectural firm. In the summer of 1850 he met Down-ing, who had gone abroad to study parks and to seek an architectural partner. He was hired, came to America the same year with the landscape man and went to work in Downing's Newburgh office. The commissions he worked on included the land-scaping for the National Capitol and for the Smith-

CONTINUED ON PAGE 72

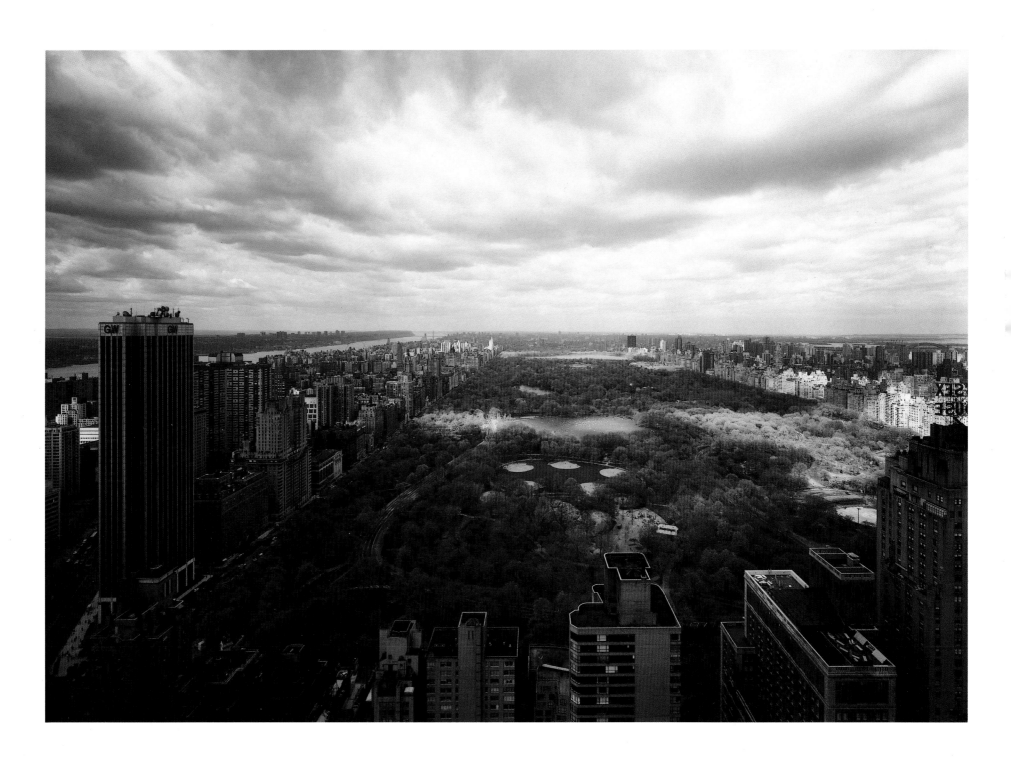

# 32
## CENTRAL PARK
### SPRING
### 1986

# 33
## CENTRAL PARK
### WINTER NIGHT
### 1982

sonian Institution. He stayed on in Newburgh after Downing's death in 1852, practicing his profession, and married a local girl. In 1857, the year his book *Villas and Cottages: A Series of Designs Prepared for Execution in the United States* was published, Vaux moved to New York. Then came the work on the Greensward plan, done mostly at his house at 136 East 18th Street.

*When the drawing of the plan of Central Park to go into the competition was being made at my father's house in 18th Street, in conjunction with Mr. Frederick Law Olmsted [his son recalled], there was a great deal of grass to be put in by the usual small dots and dashes, and it became the friendly thing for callers to help on the work by joining in and adding some grass to Central Park.*

The two men worked together, usually on Sundays and at night, as Olmsted was occupied with his superintendency during the day. They explored the ground that Olmsted knew so well, talking over every part of it to the last detail before coming to any decision.

... The key to the Greensward plan lay "in adopting the actual situation to its purpose. . . ." The designers considered the park to fall naturally into two sections, upper and lower, with the dividing line at what is now the 85th Street Transverse Road.

*The horizon lines of upper park [they wrote], are bold and sweeping and the slopes have great breadth in almost every aspect in which they may be*

CONTINUED ON PAGE 77

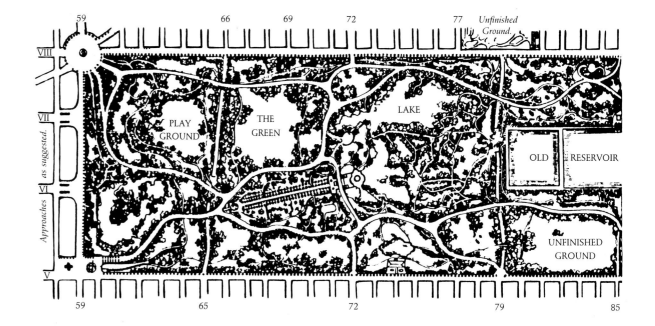

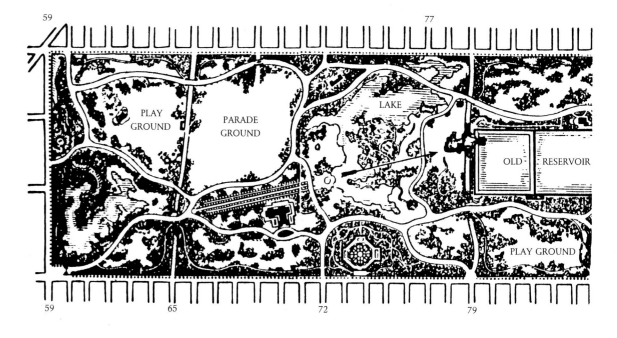

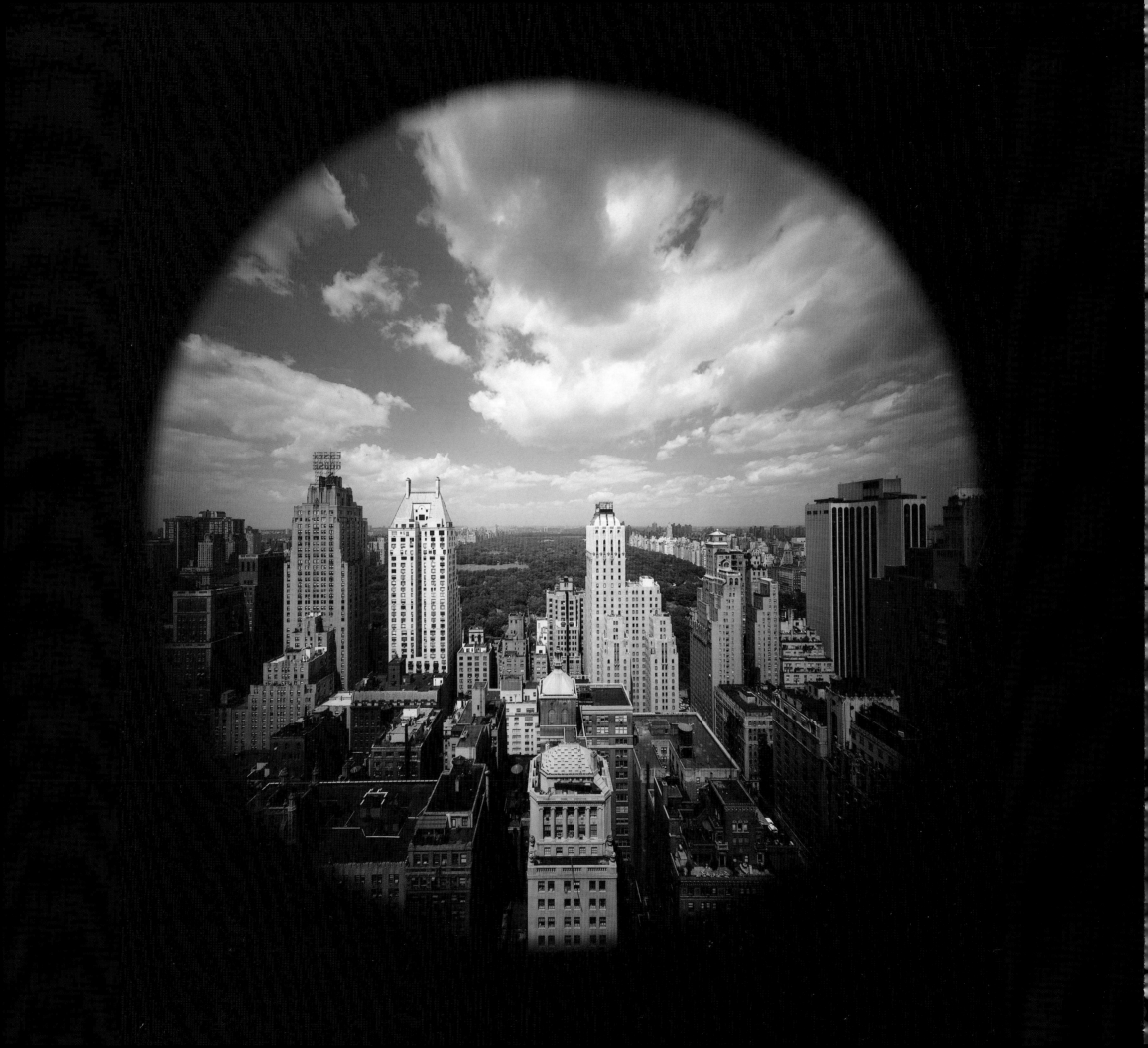

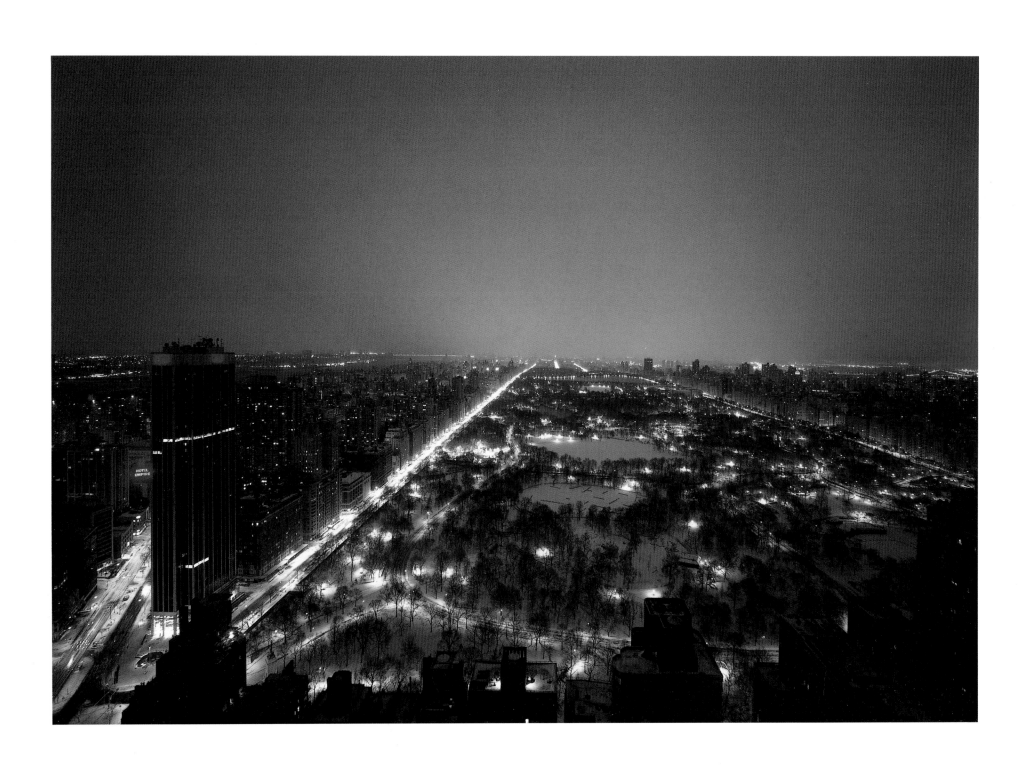

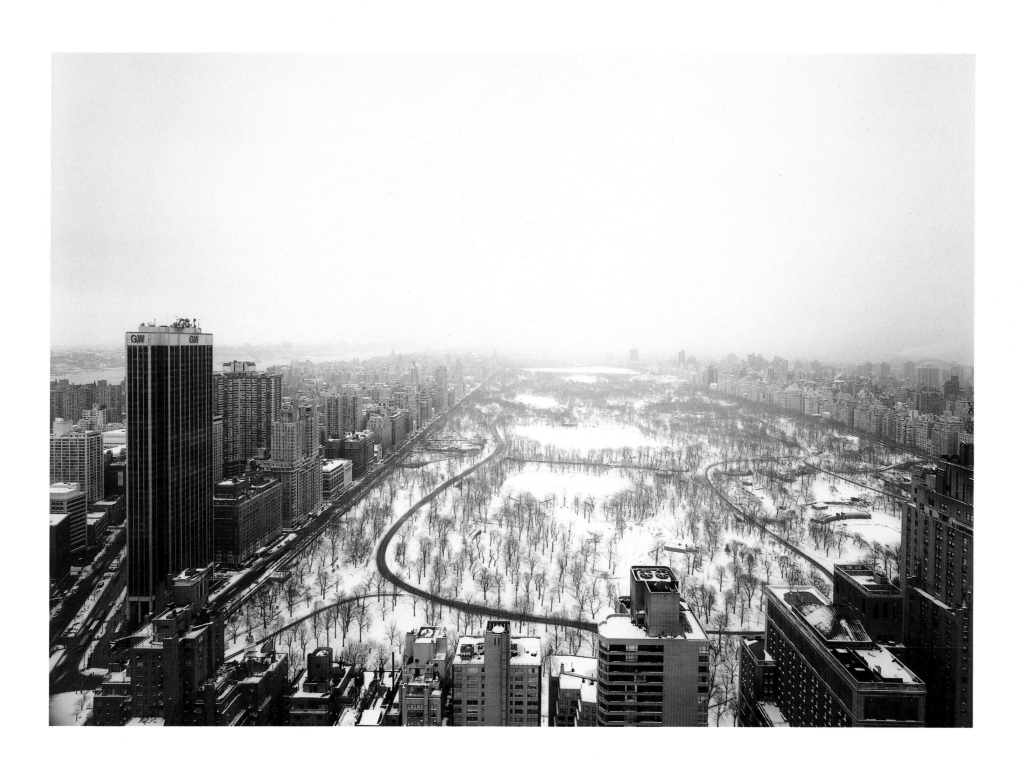

# THE CENTRAL PARK RESERVOIR

## 1982

. . . Olmsted and Vaux were the first to introduce the contemporary notion of traffic separation on a large scale, an invention that "Capability" Brown had devised a century before for a private English park. As for east-west traffic, a serious problem, they provided four sunken transverse roads that in no way interfered with the over-all design. An amusing coda to the Greensward text was the designers' explanation for the twisting drives, the bane of car drivers:

*It will be perceived that no long straight drive has been provided on the plan; this feature has been studiously avoided, because it would offer opportunities for trotting matches. The popular idea of the park is a beautiful open space, in which quiet drives, rides, and strolls may be had. This cannot be preserved if a race-course, or a road that can readily be used as a race-course, is made one of its leading attractions.*

The hot-rodders of the day were the fast trotters who, in the late 1850's, clustered daily on what is now Broadway in the neighborhood of 90th Street; they were a nuisance that had to be barred from the park.

. . . Nature in Manhattan in 1858 was hardly the Goddess fair; she was a grubby, unkempt urchin in need of far more than a bath. After Greensward took the prize, Olmsted, continuing as superintendent, became Architect-in-Chief and Vaux, Assistant to the Architect-in-Chief. Work on the park, begun in 1857, went on at a faster pace. Loads of loose rock continued to be removed and used to fashion a temporary park wall; the drained swamps were cleared and several basins made ready for water. To carry out the Greensward design tremendous jobs of blasting and filling had to be done. Up to the end of 1873, 4,825,000 cubic yards of stone, earth and topsoil (amounting to 10,000,000 one-horse cartloads) were moved out of or into the park. The original soil, a glacial outwash with little organic matter, was treated with fertilizer and top soil, 500,039 cubic yards of the latter being spread in the park from 1858 to 1865.

Paths, drives, bridges and transverse roads were built, and drainage, a key part of any park, seldom considered because invisible, took the form of sixty-two miles of earthenware drainage pipe. Irrigation was provided by hydrants placed along the drives and on the lawns. Twelve and one-half miles of water pipe were laid by 1861. The first tree was planted in the park on October 17, 1858. For reasons of economy, two nurseries with 25,000 trees were established on park land. Most of the seedlings came from nurseries then on the city's periphery, although some were imported from Scotland; 17,300 trees and shrubs were set out in 1859, 16,200 in 1860, 52,700 in 1861, 74,730 in 1862—figures that indicate the extent of the operation. By 1873 it was estimated that, all told, four to five million trees, shrubs and vines had been planted. Only 42 species of trees were found growing on the park site prior to the clearing; by 1873 there were 402 species of deciduous trees and shrubs, 149 nonconiferous evergreens and "American" plants in open ground, 81 conifers, and 815 hardy perennials and alpines.

. . . The park was immediately popular from the moment a portion of it was opened in the fall of 1858. As the landscaping spread north from 59th street, visitors came in growing numbers. George Templeton Strong, the diarist who saw and recorded everything going on in the city, was among the early explorers.

*Improved the day by leaving Wall Street early [he wrote on June 11, 1859], and set off with George Anthon and Johnny to explore the Central Park, which will be a feature of the city within five years and a lovely place in* A.D. *1900, when its trees will have acquired dignity and appreciable diameters. Perhaps the city itself will perish before then, by growing too big to live under faulty institutions corruptly administered. Reached the park a little before four, just as the red flag was hoisted—the signal for the blasts of the day. They were all around us for some twenty minutes, now booming far off to the north, now quite near, now distant again, like a desultory "affair" between advanced posts of two great armies. We entered the park at Seventy-first Street, on its east side, and made for "The Ramble," a patch just below the upper reservoir [the Old Reservoir]. Its footpaths and plantations are finished, more or less, and it is the first section of the ground that has been polished off and made presentable. It promises very well. So does all the lower park, though now in most ragged condition: long lines of incomplete macadamization, "lakes" without water, mounds of compost, piles of blasted stone, acres of what may be greensward hereafter but is now mere brown earth; groves of slender young transplanted maples and locusts, undecided between life and death, with here and there an arboricultural experiment that has failed utterly and is a mere broomstick with ramifications. Celts, caravans of*

CONTINUED ON PAGE 81

*contemplated. As this character is the highest ideal that can be aimed at for a park under any circumstances, and as it is in most decided contrast to the confined and formal lines of the city it is desirable to interfere with it, by crossroads and other constructions, as little as possible. Formal planting and architectual effects, unless on a very grand scale, must be avoided. . . .*

They saw the lower park—and it is interesting to follow them across the then unsightly desert—as "far more heterogeneous in its character" requiring "much more varied treatment."

*The most important feature in its landscape, [they continued], is the long rocky and wooded hill-side lying immediately south of the Reservoir. [The hillside is the one now crowned by the towered Belvedere, and the reservoir referred to the old one, which occupied the site of the Great Lawn until 1929.] Inasmuch as beyond this point there do not appear to be any leading natural characteristics of similar consequence in the scenery, it will be important to draw as much attention as possible to this hill-side, to afford facilities for rest and leisurely contemplation upon the rising ground opposite and to render the lateral boundaries of the park in its vicinity as inconspicuous as possible.*

CONTINUED ON PAGE 78

TOP:
First study of design for Central Park
LEFT:
Map of Central Park, 1868

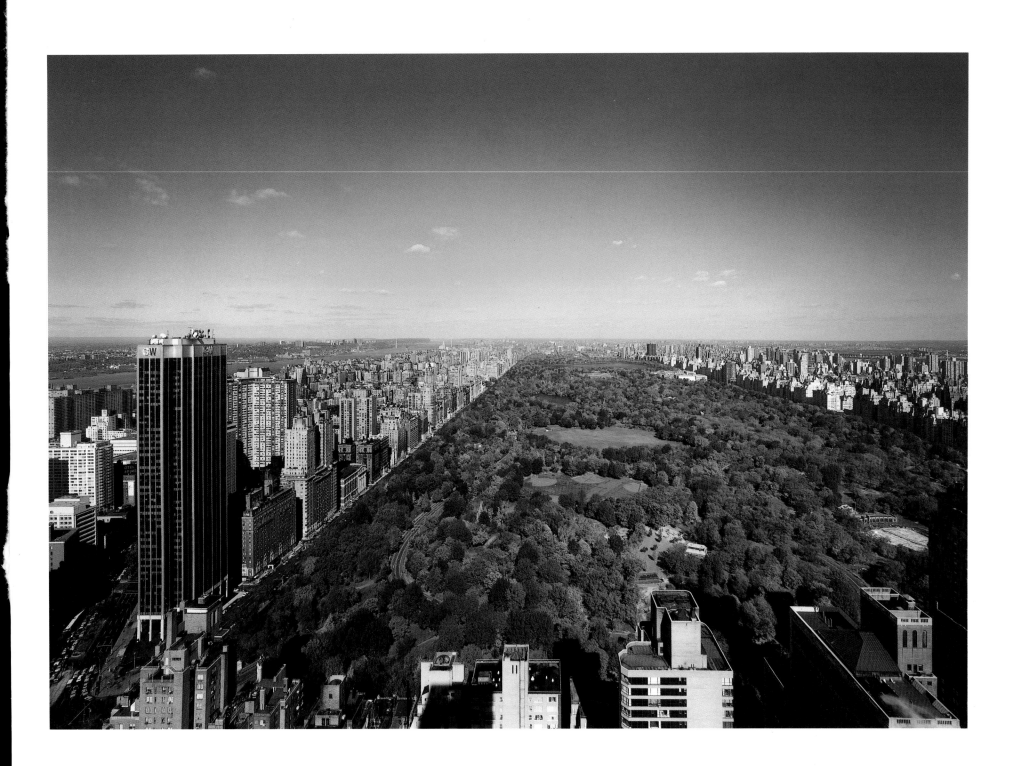

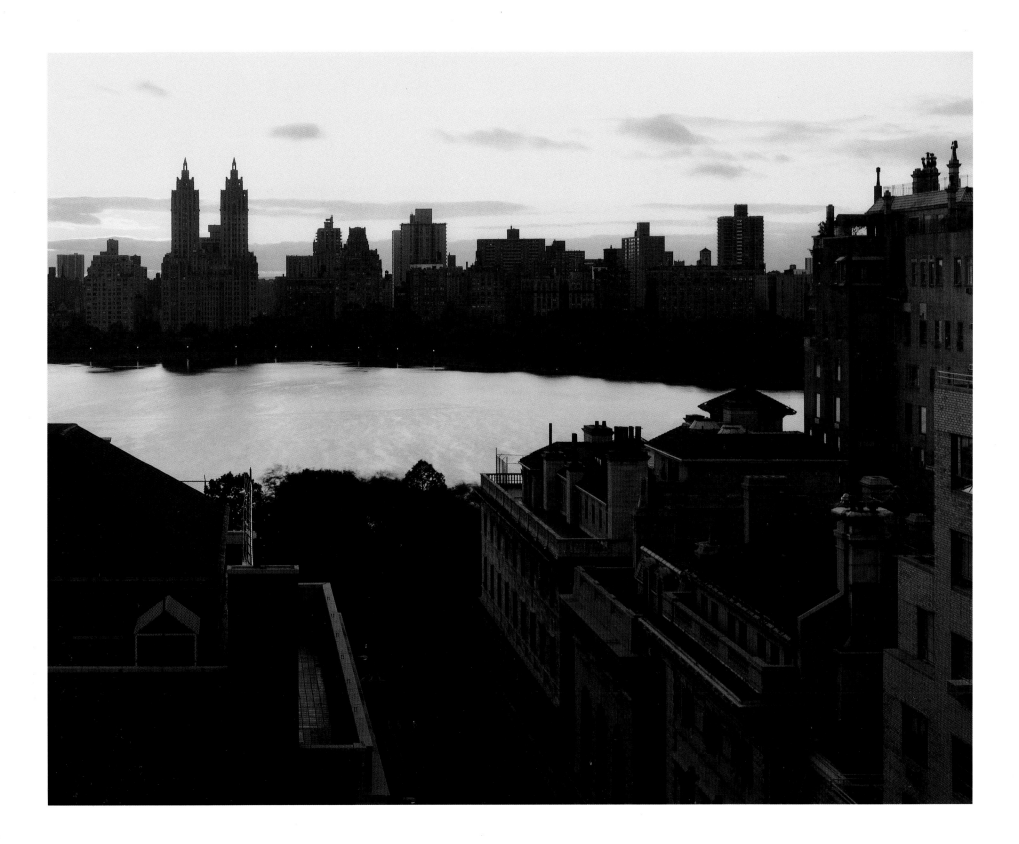

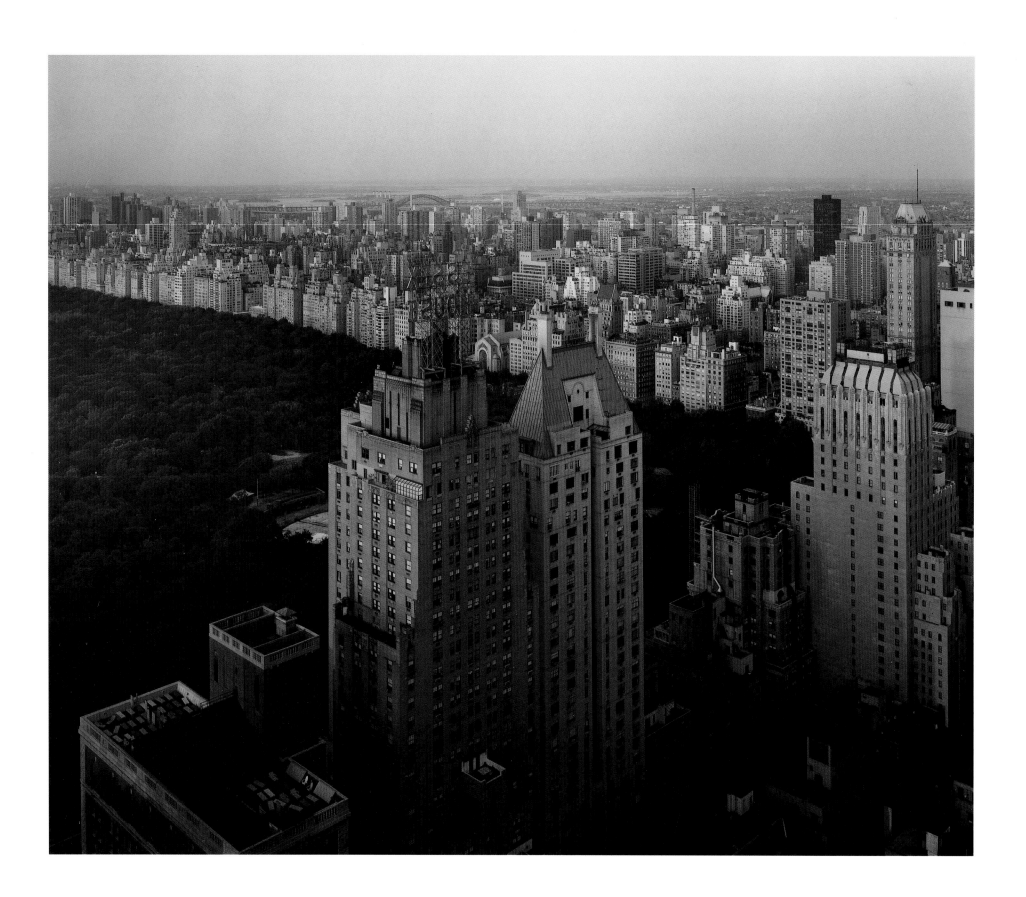

# SOUTHEAST CORNER OF CENTRAL PARK
# AND UPPER FIFTH AVENUE
# ACROSS CENTRAL PARK SOUTH

## 1981

*dirt carts, derricks, steam engines, these are the elements out of which our future Pleasaunce is rapidly developing. The work seems pushed with vigor and system, and as far as it has gone, looks thorough and substantial. . . .*

. . . Oliver Wendell Holmes was another early visitor. "The Autocrat of the Breakfast Table" stopped off in the city while taking home his son, Captain Oliver Wendell Holmes, Jr., of the 20th Massachusetts, wounded a second time at Antietam.

*The Central Park is an expanse of wild country [observed the elder Holmes in 1862], well crumpled so as to form ridges which will give views and hollows that will hold water. The hips and elbows and other bones of Nature stick out here and there in the shape of rocks which give character to the scenery, and an unchangeable, unpurchasable look to a landscape that without them would have been in danger of being fattened by art and money out of all its native features. The roads were fine, the sheets of water beautiful, the bridges handsome, the swans elegant in their deportment, the grass green and as short as a fast horse's winter coat. I could not learn whether it was kept so by clipping or singeing. I was delighted with my new property,— but it cost me four dollars to get there [from 23rd Street and Fifth Avenue], so far was it beyond the Pillars of Hercules of the fashionable quarter.*

In the 1860's there were many vacant lots south of 59th Street, and the land adjacent to the park was almost completely unimproved. Had Holmes returned in 1876, when the park was considered completed, he would no doubt have been astonished to see how far north the city had advanced.

Holmes's delight in Central Park reflected the delight of all, and in the last year of the Civil War visitors numbered over seven million. The charm and novelty of the setting that by then was the city's chief attraction was accented by the presence of deer and sheep. The herd of deer soon disappeared but, for years, the presence of sheep made the park seem almost exotic in contrast to the commercial and industrial city.

. . . The most serious invasion of the park took the form of gifts, several of which were personal memorials partly financed by the city. The more prominent of the gifts have been the Wollman Skating Rink in 1950, the Hans Christian Andersen statue in 1956, the Alice-in-Wonderland group in 1959, the Delacorte (Shakespeare) Theatre in 1963 and the disastrous Loula D. Lasker Pool-Rink. Little wonder that the park has won the name of "Central Park Memorial Cemetery." The attitude of an administration that permitted these contraventions to the Olmsted and Vaux ideal is in sharp contrast to the common sense and high purpose of the Londoners in charge of Hyde Park. "Well, some

suggestion for exploiting Hyde Park is put forward nearly every week," remarked one of the park's guardians recently, "and the reason why it stays unspoilt is because people damn well see that it stays so!"

Much of the permanent damage to the park has taken place since the war, in the very decades that the nation has presumably known an "artistic explosion." For all today's self-consciousness about the importance of "ART," the particular work of art called Central Park has been forgotten. Some have speculated that it was misnamed in the 1850's. Had it been called, for example, "The New York Public Gardens" there would have been no desecration. The sheep would still be on the Sheep Meadow and the Swanboats on the pond (there until 1924), much as they still are in the Boston Public Gardens. The word "garden," like the flaming sword at the Garden of Eden, might have protected the greensward.

. . . New Yorkers must learn the hard way, as they have in the preservation of landmarks. Commissioner Hoving has pointed out on more than one occasion that the beginning of any program for the park lies with a thorough study of the reports of Olmsted and Vaux. Not only will such a study reveal that the problems are generations old but also, and this is more important, that Central Park is, in truth, a garden, a work of art.

HENRY HOPE REED AND SOPHIA DUCKWORTH
*Central Park: A History and a Guide,* 1967

# 3 8
# ST. PATRICK'S CATHEDRAL
## 1 9 8 1

Where on the varied earth, in the whirlwind of innumerable conflicts, shall the young people of today go to breathe the air of the new times? There can be no doubt: a crust is scaling off of our stupefied societies. New skin! Spring! Renewal! The young are eager for a change of air. I feel myself young also; I have the desire, before dying, to share in something live and changing. I do not wish to be charming, but to be strong. I do not wish to be frozen, I do not wish to maintain things, but to act and create.

I cannot forget New York, a vertical city, now that I have had the happiness of seeing it there, raised up in the sky.

LE CORBUSIER
*When the Cathedrals Were White, 1947*

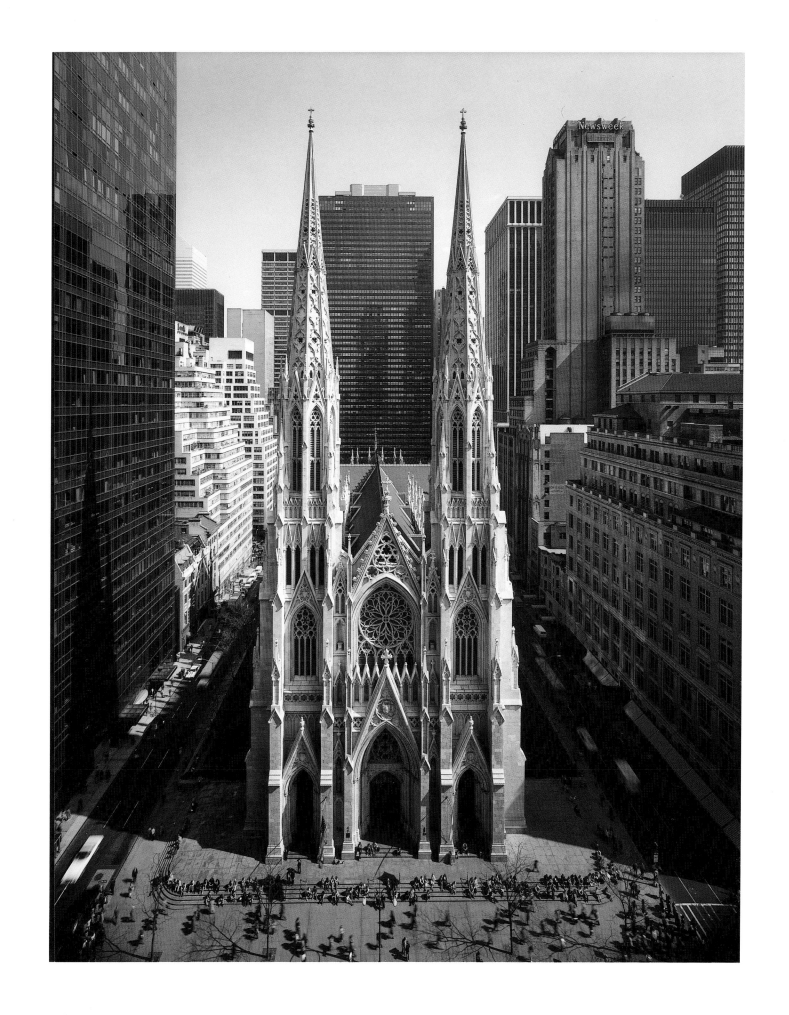

# CITICORP CENTER ACROSS ROOSEVELT ISLAND
## FROM QUEENS
### 1984

New York is nothing like Paris; it is nothing like London; and it is not Spokane multiplied by sixty, or Detroit multiplied by four. It is by all odds the loftiest of cities. It even managed to reach the highest point in the sky at the lowest moment of the depression. The Empire State Building shot twelve hundred and fifty feet into the air when it was madness to put out as much as six inches of new growth.

. . . Manhattan has been compelled to expand skyward because of the absence of any other direction in which to grow. This, more than any other thing, is responsible for its physical majesty. It is to the nation what the white church spire is to the village—the visible symbol of aspiration and faith, the white plume saying that the way is up.

E. B. WHITE
*Here Is New York,* 1949

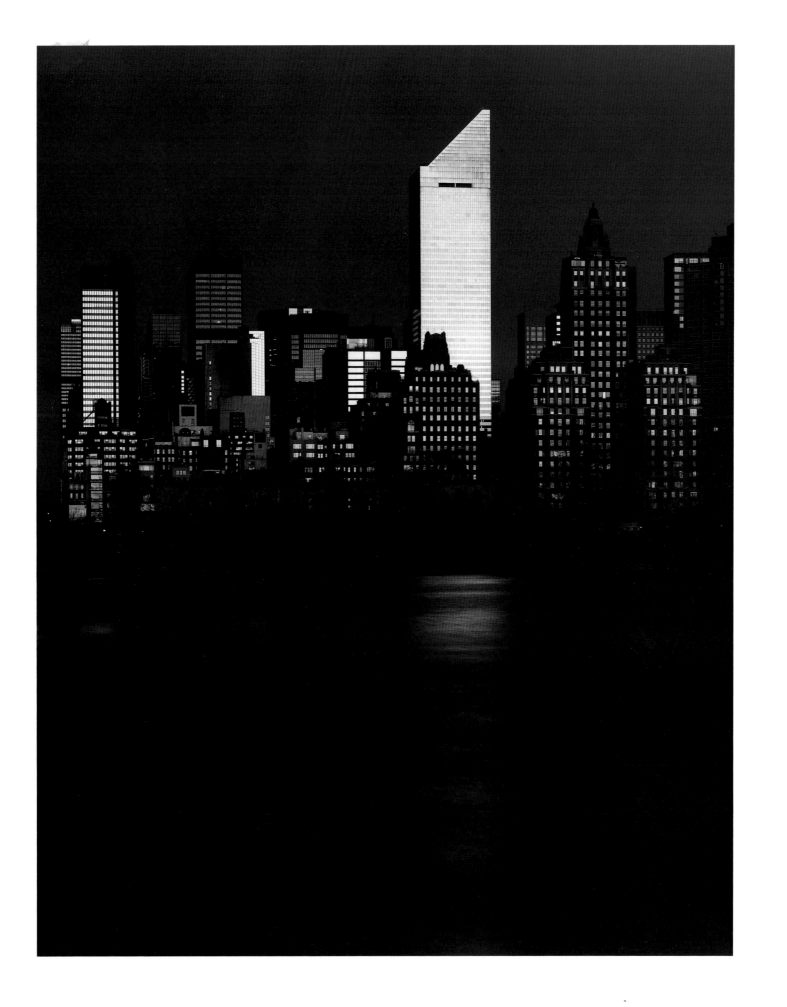

# 40

## THE 59TH STREET BRIDGE,
## "BIG ALLIS," AND THE UPPER EAST SIDE
### FROM CITICORP AT COURT SQUARE, LONG ISLAND CITY
#### 1990

The City has sins enough to answer for, Heaven knows; but it is painted blacker than it deserves, and the bright hues that belong to it are hidden under the veil of censure.

J. H. BROWNE

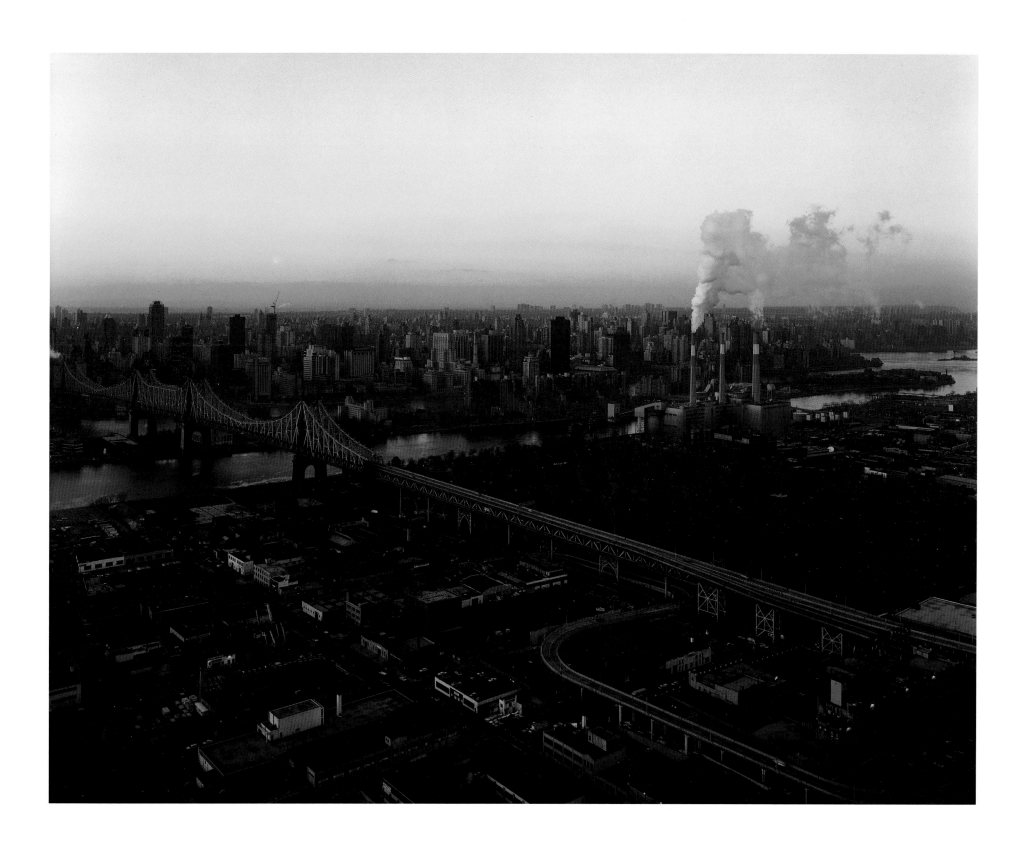

# 41

# VIEW SOUTH FROM THE
# OLD ELEVATED WEST SIDE HIGHWAY
# AT CHAMBERS STREET

## 1981

Washington Market on the lower West Side used to be a quiet place by day, but, at night, when the trucks loaded with vegetables and fruit from the country came rumbling down the cobblestone streets to the four-story brick buildings of the commission merchants, it turned busy, noisy, lurid, crowded, and exciting. . . .

The market was knocked down and bulldozed in the 1970s—the vegetable market moved up to Hunts Point in the Bronx—and today the area is mostly parking lots and weeds and overgrown rubble. There is a new apartment complex to the north (with a park); the World Trade Center and other large buildings to the south; some old and handsome brick buildings along Greenwich Street to the east; and the abandoned structure of the former West Side Highway to the west. Beyond that, there is landfill where Pier 19 once stood. In this wasteland of civic improvement, there is one solitary and ancient four-story red brick building still standing. It's on the corner of Warren Street and West Street—No. 179 West Street—and there is a tall weeping willow growing on the north side, a plane tree on the south, and a substantial jungle of ailanthus and lesser shrubs all around. On one side, along the sidewalk, there is a post-and-lintel arrangement of three huge stone slabs—a formal entrance leading only to weeds. It once formed the doorway to a commission merchant's building, probably, since there are faded signs and letters still visible on the vertical stone. On the doorsill of the front door (a door with many locks) there is a mosaic of brown and white tiles.

The view from the fourth story must be remarkable, I thought: a sweeping vista over and through the young saplings growing on the West Side Highway; a grand look both up and down the Hudson. There was a light in a window on the second floor, but no signs of life, and, since it was only nine o'clock on a Sunday morning, I did not knock on the door and inquire as to who lived inside and why the building was still standing. I never did find out, either, but I did hear some neighborhood opinions. . . .

The theory I liked best came from a couple of men in a bar on Greenwich Street. They were cleaning up from Saturday night; the stools were upside down on the bar, and, when I leaned in the open door, one man said, "We're closed."

I asked if they knew anything about the mysterious house.

"I understand there's somebody living in there, and he won't sell," said one of the men, who was wearing a red T-shirt. He peered out the window, across the weeds and parking lots, at the house in the distance. "He's holding up all the construction around here."

The other man glanced around, and then said, confidentially, "That house is not even on the city blueprints." He paused. "Officially, it doesn't even exist."

"That's why it's still standing," said the first.

"How can they knock it down if it doesn't exist?" said the second.

They both nodded.

JAMES STEVENSON
"House," 1981

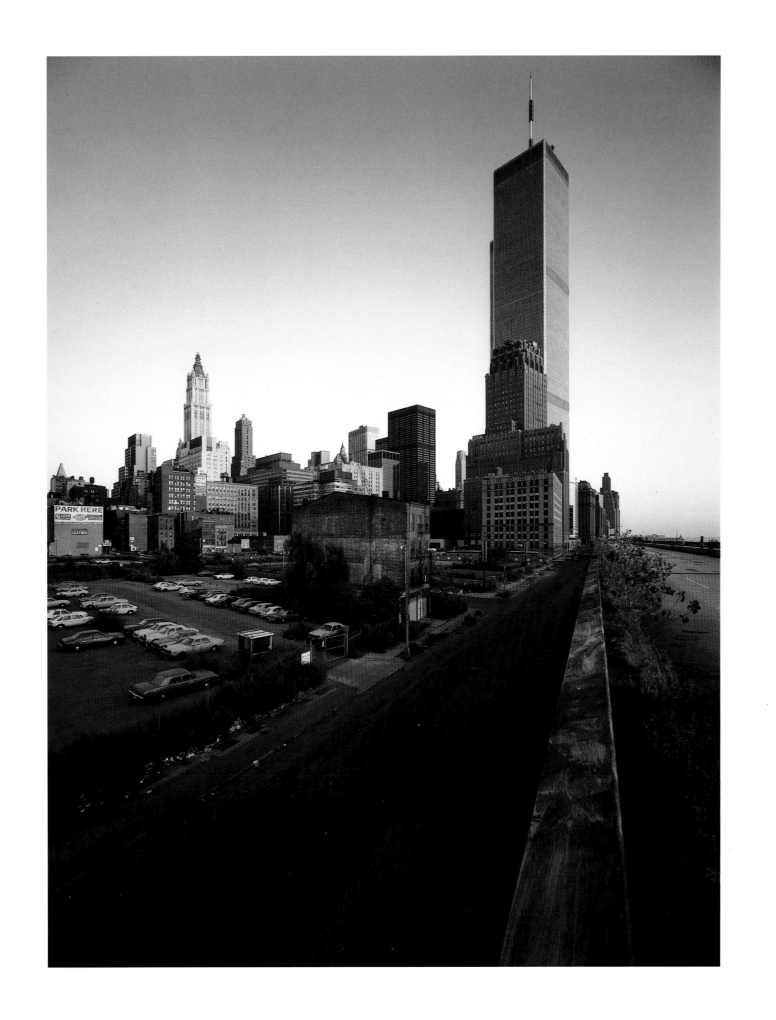

# 42
# THE JACOB JAVITS CONVENTION CENTER
## 1986

Truly the magic of her spell can never be exacted. She changes too rapidly, day by day. Realism, as they call it, can never catch the boundaries of her pearly beauty. She needs a mystic.

CHRISTOPHER MORLEY

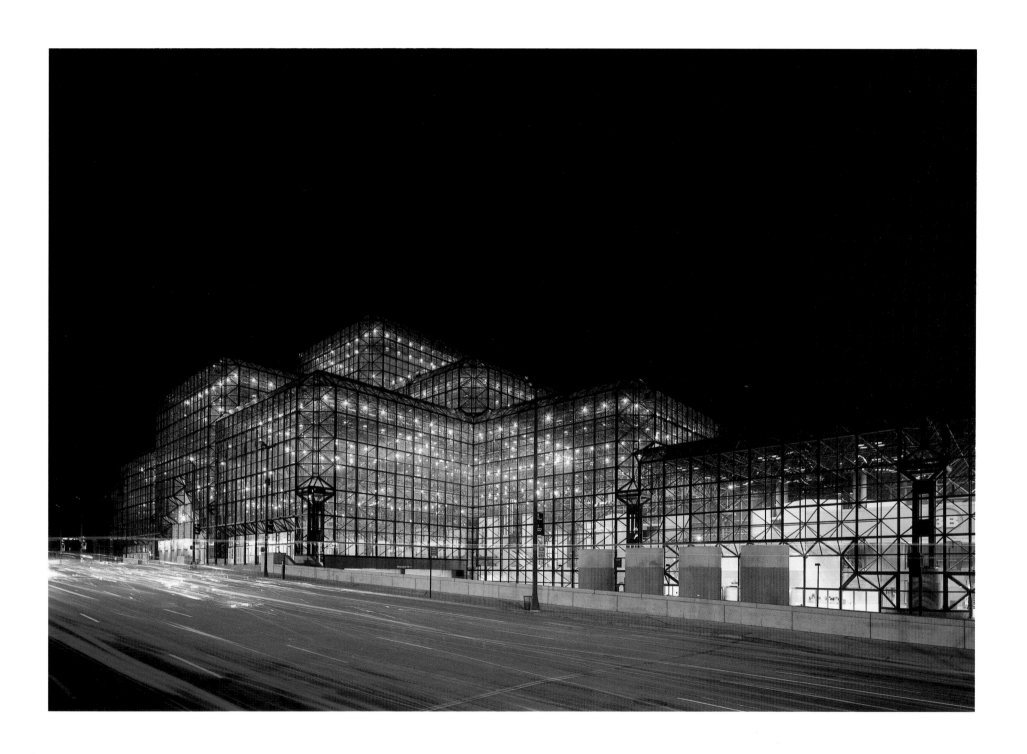

# THE QE2 AND THE WEST FIFTIES

## 1981

The Arab or the Moor probably invented the roof-garden in some long-gone centuries, and they are at this day inveterate roof-gardeners. The American, surprisingly belated—for him—has but recently seized upon the idea, and its development here has been only partial. The possibilities of the roof-garden are still unknown.

Here is a vast city, in which thousands of people in summer half stifle, cry out continually for air, more air, fresher air. Just above their heads is what might be called a county of unoccupied land. It is not ridiculously small when compared with the area of New York County itself. But it is as lonely as a desert, this region of roofs. It is as untrodden as the corners of Arizona. Unless a man be a roof-gardener he knows practically nothing of this land.

Down in the slums necessity forces a solution of problems. It drives the people to the roofs. An evening upon a tenement roof, with the great golden march of the stars across the sky and Johnnie gone for a pail of beer, is not so bad if you have never seen the mountains nor heard, to your heart, the slow, sad song of the pines.

STEPHEN CRANE
"The Roof Gardens and Gardeners of New York"

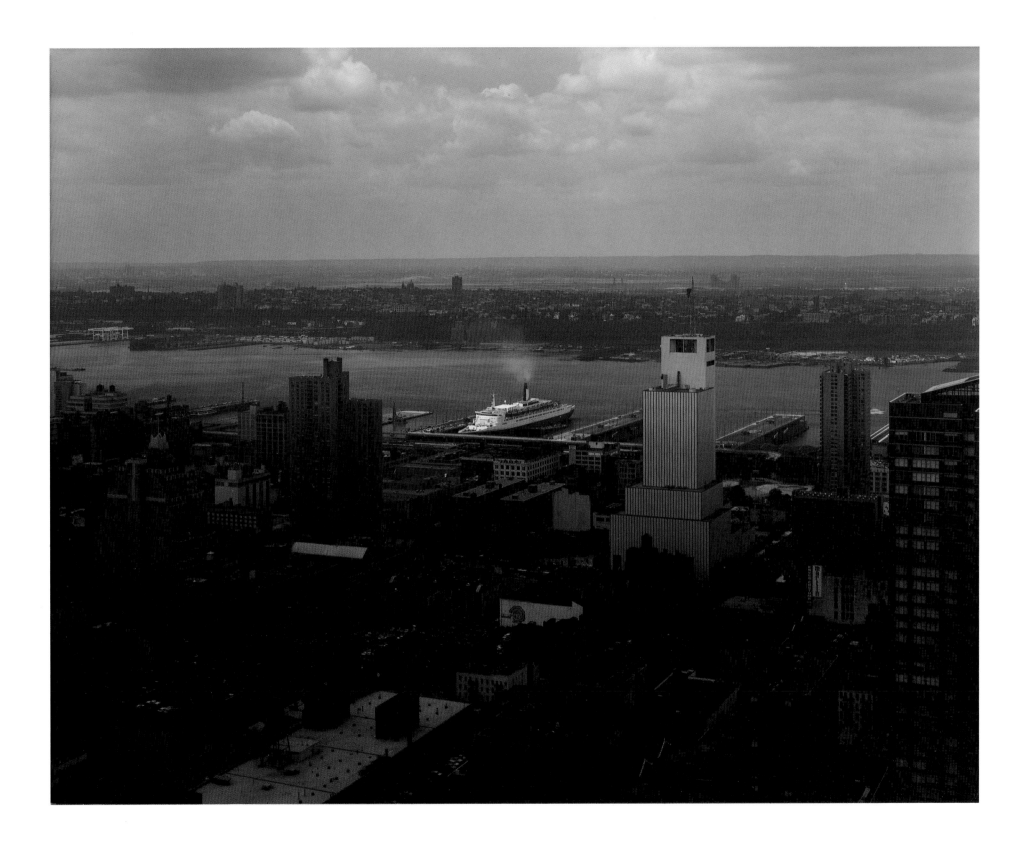

# 44

# THE HUDSON RIVER,
# FROM THE SOLDIERS' AND SAILORS' MONUMENT
# ON RIVERSIDE DRIVE
# TO THE GEORGE WASHINGTON BRIDGE
# 1990

The supper was fine and the wine was finer, and still more filling than either was the night, cold, serene, moonlit.

I had heard "The Tales of Hoffman" that evening. Its witchery, its bouquet of dreams, its haunting melodies still had full possession of me. It seemed I had become a ghost wandering through that nowhere land of Hoffman, that Venice woven of strange psychic stuffs, with those grotesque magicians and those unheard-of people, whose unreality numbed the sense of the familiar and made me tread carpets woven by gnomes in strange, nostalgic hemispheres of the soul.

I turned up Riverside Drive. It was 1 A.M. If the Barcarole and the Burgundy and the miasmatic twilight of the Grand Canal had not woven their spells over my brain, the Drive, the river and the Palisades in the distance, all covered with snow and shimmering in the moonlight like the stupendous tombstones in a forgotten necropolis of Titans, would have done so.

It was the magic moment of rare, unforgettable happenings, of vast, infernal doings, of strange and grotesque fantasies.

I sat upon the stone seat surrounding the Soldiers' and Sailors' Monument to gulp in that scene of snow-magic and lunar necromancy and mix it with the Burgundy and the myths of that madman who wrote the Tales and the wizard who translated them into sound.

I had not been sitting there more than a minute when I became aware that something tremendously unusual was going on, or rather coming up, the Drive.

CONTINUED ON PAGE 97

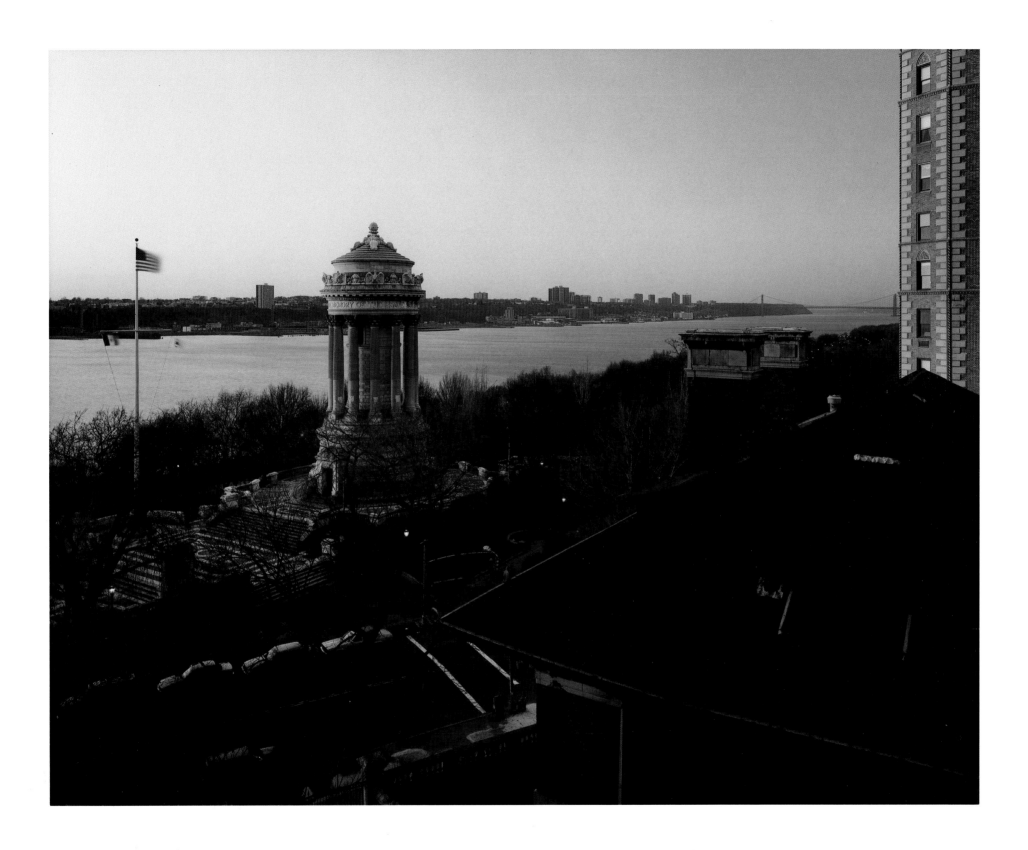

# 45 & 46

# THE CIVIC CENTER
# WITH MIDTOWN IN THE BACKGROUND
## FROM 127 JOHN STREET

## 1983

A titanic footfall, like the march of Thor, first came to my ear.

Then another and another. It was heaven-filling and measured. It was the very sound of Doom, the herald of a Finality.

I looked down the Drive and I saw the Woolworth Tower, struck clean from the rest of the building from pillar to dome, coming up the Drive. There was not a light in a single window, but at the top burned a small candle that flickered and sneezed as though it would go out at any minute.

The Tower led the most astonishing procession that ever mortal eye shall look upon. Behind the Tower tramped thunderously the Statue of Liberty. She held her torch, extinguished, in her hand. Then came Diana, from the top of Madison Square Garden; the two Library Lions, the statue of Shakespeare from the Mall in Central Park, the old City Hall Clocks, the Golden Lady from atop the Municipal Building, and last of all the Brooklyn Bridge, crawling along like a tired snake, its cables making a most unearthly racket, which nearly drowned the earth-quivering thuds of the Woolworth Tower and the Statue of Liberty.

As the Tower passed in its tremendous tramp, shimmering in the moonlight and the snow like an alabaster shaft supporting the heavens, it said to me:

"My soul is a series of pigeon-holes called rooms. I am Business. I am Profit and Loss. I am Beauty come into the hell of the Practical. Farewell! I am marching back to the deep-earth quarries whence I came."

Diana, with her arrow, pointed at the stars, said:

"I am Paganism, the ancient glory that is no more. What do I here? I have watched the moderns of Madison Square with their stupid clothes and ugly faces and unchaste forms till my heart is turned to brass and my breasts to iron. I go back to the Moon to hunt wild boars in the basin of the seas that are no more."

The two Library Lions, with melancholy manes and lack-lustre eyes, said:

"Taken from the jungle, carved into stone, set to watch traffic cops and people who believe wisdom is in books! We are the apotheosis of pacifism. We are returning to Africa, where there is still some freedom and wisdom!"

Shakespeare, his head poised like a planet in the ether, said:

"Farewell farewell to all that humbug called *vers libre*. I return to Titania and Ariel. I cannot dream there in the Mall. It is only the children who have made life livable for me there. Besides, I'm afraid the Rubber Building will fall on me."

The old City Hall Clocks, martyrs to the weather and fire, their gilded letters half faded and their hands chafed and cracked, said:

"We have told our last lie. There is no such thing as time; there are only timepieces. We are going to the tomb of Immanuel Kant at Koenigsberg, he who destroyed the objectivity of Time and Space, and hence abolished clocks. We shall crawl into his coffin and sleep. Sleep! Sleep! That's what all clocks need!"

The Golden Lady from the summit of the Municipal Building said:

"Justice is a dice-box. The rich always win, while the poor get the box. I'm going in yon icy river at a warm spot near Hastings."

The Brooklyn Bridge was making such an uproar that I could not hear what it said.

I leaped upon the bridge, intending to follow that strange procession to the end. But a powerful grip on my shoulder restrained me.

"D'ye want ter freeze to det, hey?"

It was a policeman. I gave him a bundle of cigars I had in my pocket and walked toward Broadway.

But as I left him the policeman, strangely enough, was humming the Barcarole.

BENJAMIN DE CASSERES
"The Resignation of New York," 1925

97

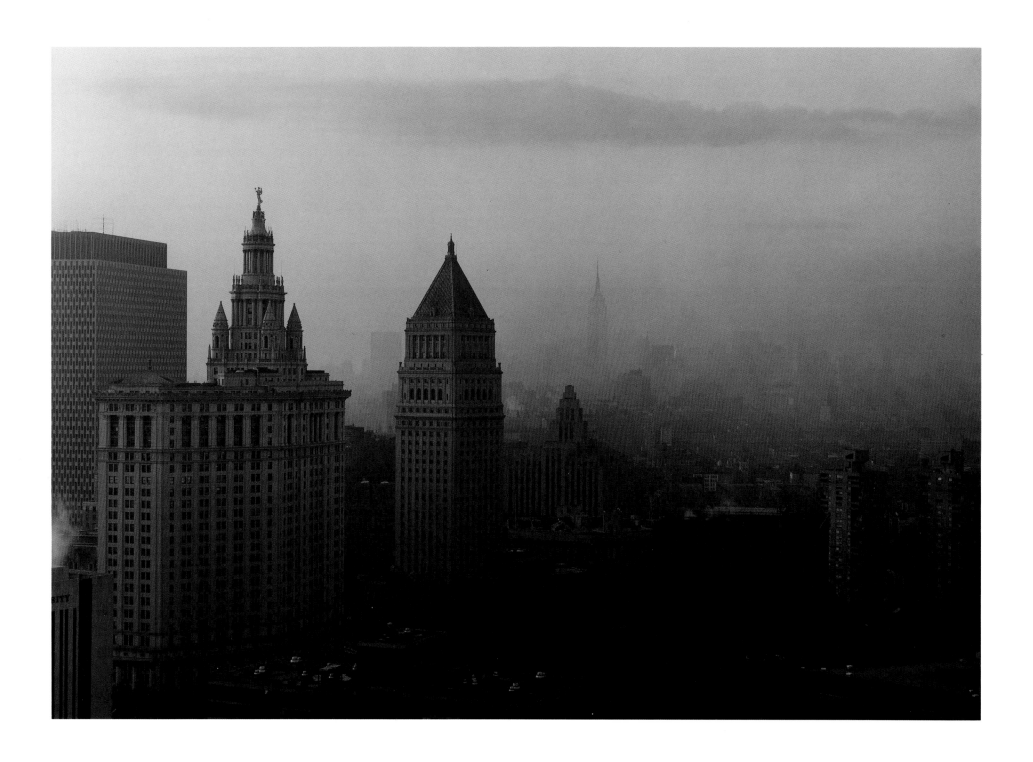

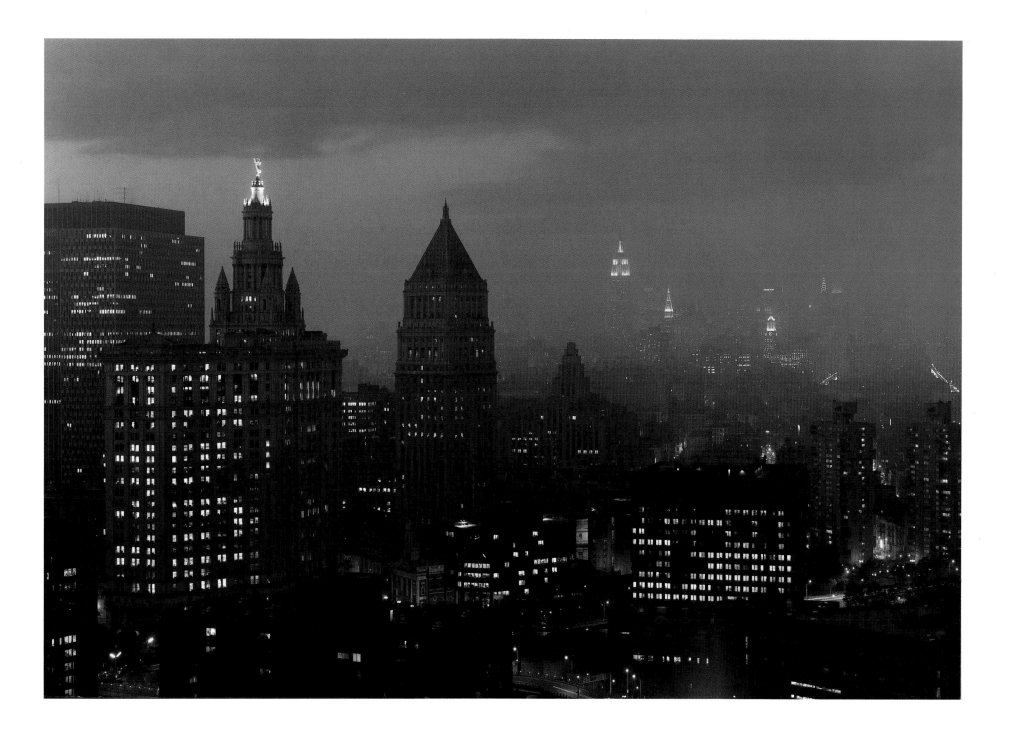

# 47

# LOOKING NORTH UP BROADWAY
# AT THE WOOLWORTH BUILDING AND CITY HALL

## 1989

There is nothing in contemporary high-rise like the inspiration that—against all the odds—made the neo-Gothic Woolworth Building one of the two most endearing skyscrapers in New York (a neo-Gothic *skyscraper?!*), with its crockets and ogees, its tracery and buttresses, its mullions and pilasters, not to mention its ecclesiastical lobby, where joining an elevator is suspiciously like entering a confessional. There is a famous photograph, taken from an aircraft well over half a century ago, of the building's topmost pinnacles rising improbably above the New York overcast, a phantom shape that might have belonged to Dracula. Happily, the Woolworth—like the Chrysler midtown—is still there, standing bravely representative of an age that perhaps had more taste than ours.

GEOFFREY MOORHOUSE
*Imperial City: New York,* 1988

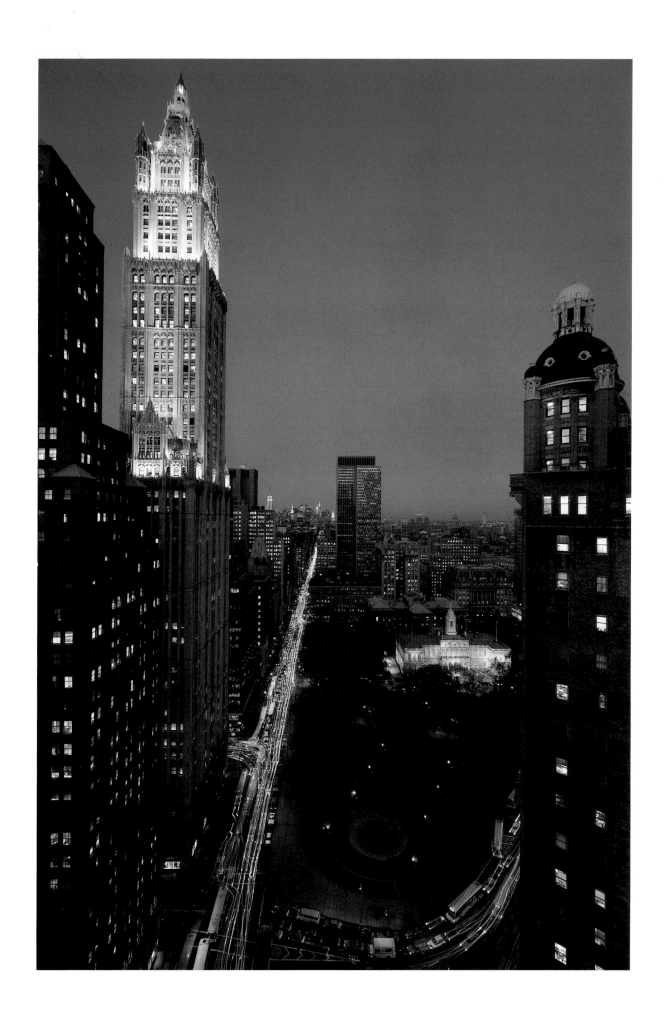

# 48

# THE WILLIAMSBURG BRIDGE
# LOOKING TOWARD MANHATTAN AT DAWN
## 1981

A poem compresses much in a small space and adds music, thus heightening its meaning. The city is like poetry: it compresses all life, all races and breeds, into a small island and adds music and the accompaniment of internal engines. The island of Manhattan is without any doubt the greatest human concentrate on earth, the poem whose magic is comprehensible to millions of permanent residents but whose full meaning will always remain elusive.

E. B. WHITE
*Here is New York,* 1949

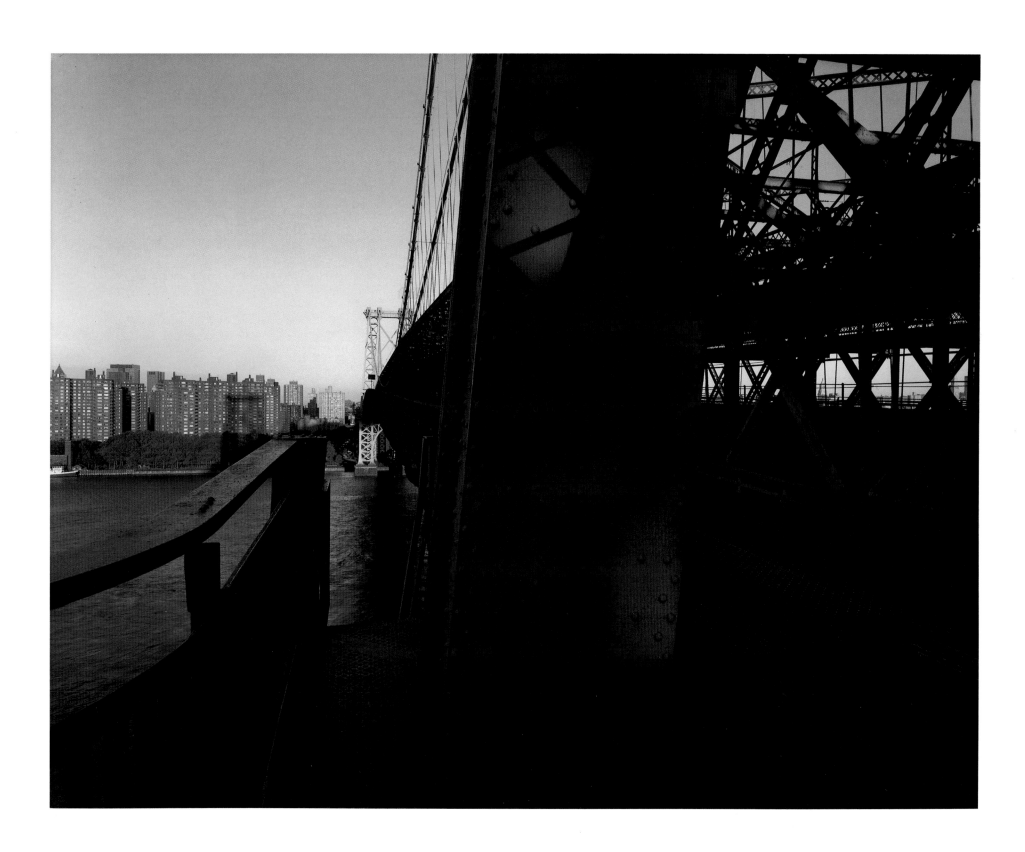

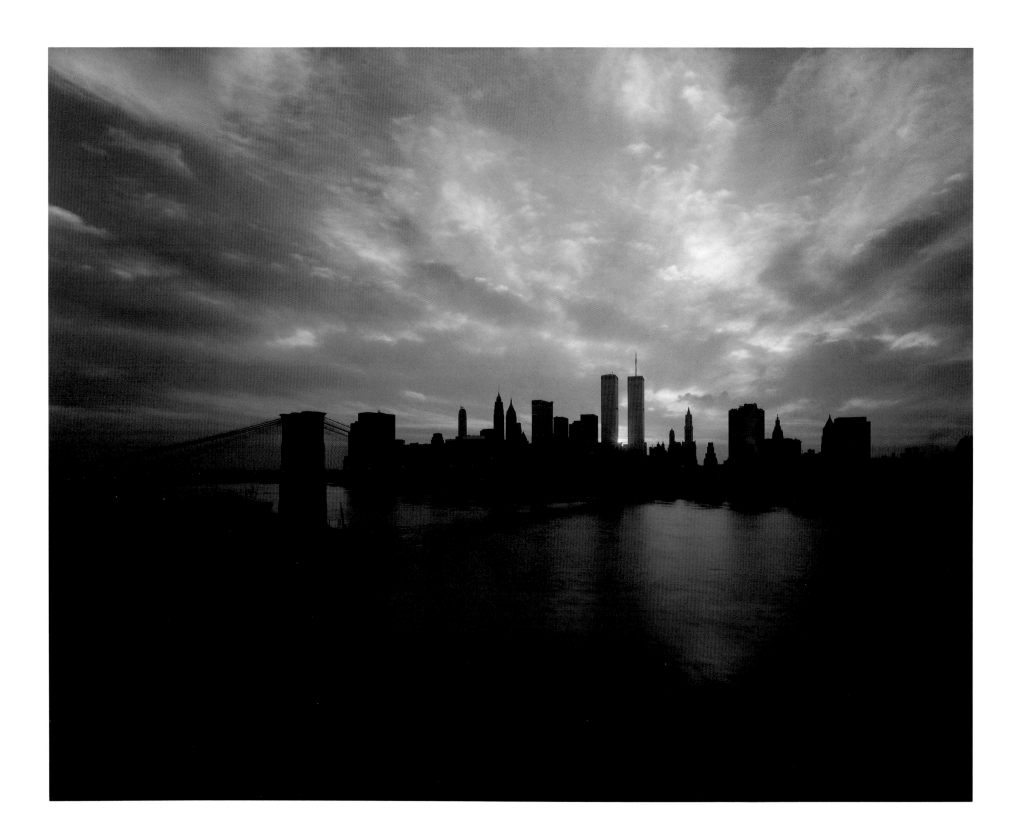

# THE BROOKLYN BRIDGE AND LOWER MANHATTAN
## FROM THE MANHATTAN BRIDGE
### 1981

Strangers entering the walled cities of medieval Europe and Asia must have felt a bit like this as they passed beneath the ramparts into the mysterious, protective but slightly forbidding communities within. But neither Europe nor Asia nor anywhere else can now offer anything to compare with the walk across the Brooklyn Bridge. There is nothing to match it in any land: not that marvelous Baroque traverse of the Charles Bridge toward the heights of Hradcany in Prague; not a crossing of the Tiber by Castel Sant'Angelo and a long stroll to the monumental embrace of St. Peter's Square in Rome; not a walk through the bazaars of Varanasi to the teeming religious devotion along the Ganges ghats; not a descent from the hillside of Galata across the Golden Horn at Istanbul into the dusty but still intoxicating legacy of what was once Byzantium. Not even such lustrous passages as these can quite compete with the sensation of crossing the Brooklyn Bridge toward the island of Manhattan in the City of New York. The others have great visual drama, too, and are brushed even more with stirring memories of the past. But here alone the stranger feels that he has come upon an epic still being made.

GEOFFREY MOORHOUSE
*Imperial City: New York,* 1988

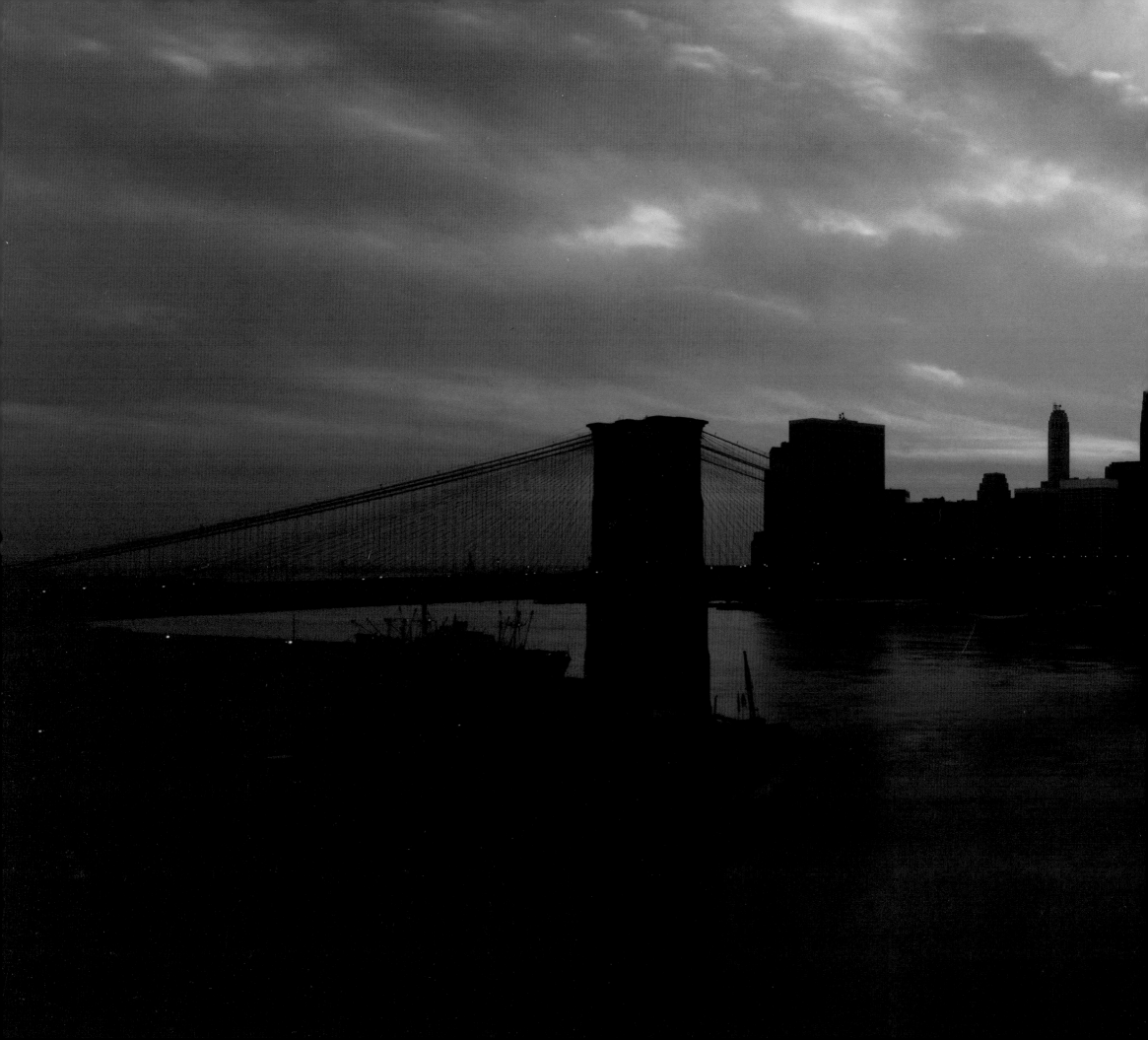

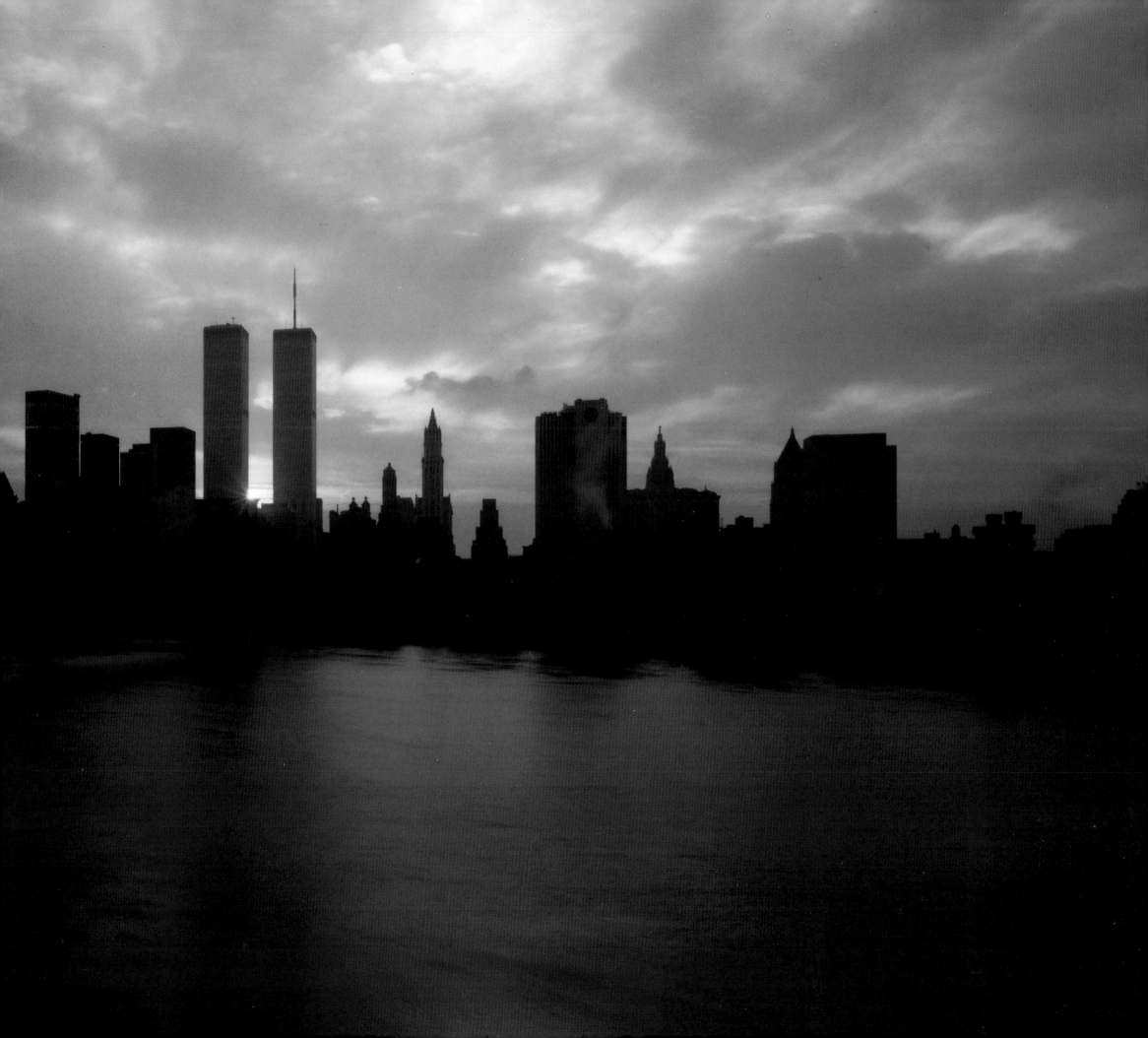

# THE BROOKLYN BRIDGE AND LOWER MANHATTAN
## FROM ONE MAIN STREET, BROOKLYN
### 1981

Seen from a distance, the full complexity of [the Brooklyn Bridge's] tautened wires that have enabled this marvel to stand proud for a century and more appears as delicately beautiful as the radial filaments of a spider's web.

Insofar as a suspension bridge stands on anything, the crucial engineering here was that put into the two great piers that counterbalance each other across the river, one on the Brooklyn shoreline, the other at the Manhattan water's edge. When John Roebling began to plan the bridge that caused his death, he first conceived those structures in the style of the massive pylons that form gateways to the temples at Edfu and elsewhere along the River Nile; and although he modified his notion before the drawings were finished, so that the New York piers are much less wedge-shaped than originally planned, a whiff of old Egypt lingers in them still. In spite of their hugeness, granite block upon ponderous block, the piers are graceful. They, more than anything else, have ensured that the Brooklyn Bridge is wonderfully in scale and in tune with its surroundings, though these have changed out of all recognition since the bridge was built. This is quite a trick, when you think of it.

For in 1883 there wasn't a skyscraper in sight, either here or anywhere else in New York. If you look at photographs of the bridge taken at about that time, when the spire of Trinity Church was the tallest thing on Manhattan (at 280 feet), the Brooklyn Bridge is easily the dominating feature in the entire vista. It looms above the Fulton Ferry terminus at the Manhattan side, as it does above all the waterside buildings on the Brooklyn shore, while the fishing boats and other craft tied to the banks or moving along the East River are reduced to the stature of cockleshells. It looms and it dominates—as though John Roebling had designed it not for his own times, but to harmonize with the Skyscraper Age to come. And now the bridge splendidly holds its own, not smothered (as Trinity Church has been smothered) by the towering range of Progress up ahead. Seen as a foreground to that skyline, it puts the skyscrapers in perspective, as well as giving the composition a touch of ageless class. Whatever they may do to the butt end of Manhattan in the future, the Brooklyn Bridge will have its place somewhere in the emotional center of the piece. It fits.

GEOFFREY MOORHOUSE
*Imperial City: New York,* 1988

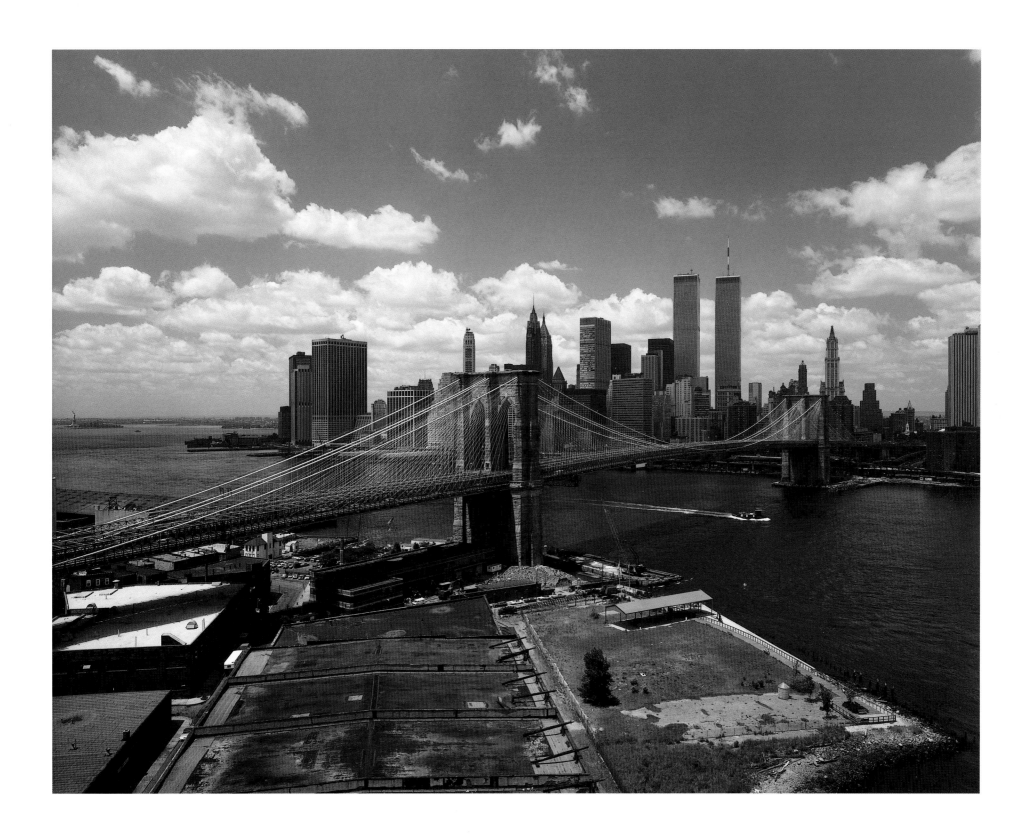

# THE BROOKLYN BRIDGE CENTENNIAL
## MAY 24, 1983

One of the barges transformed itself into the Statue of Liberty, with sparks bursting out of the torch until you had the feeling that nothing couldn't be duplicated: planets, Miss Liberty, Mayor Koch. And New York was the dream that dreamt itself, a monster out of the Old World that could never rest, spitting ideals like fireworks—liberty, brotherhood, and zero-coupon bonds. Wall Street, Chase Manhattan, the Seventh Regiment Armory were only phantom stations on a grid. Events, statues, streets were nowhere as powerful as the myth of New York: smoke and fire out of a fabricated torch, a bit of neon on the river. That was the New World.

JEROME CHARYN
*Metropolis,* 1986

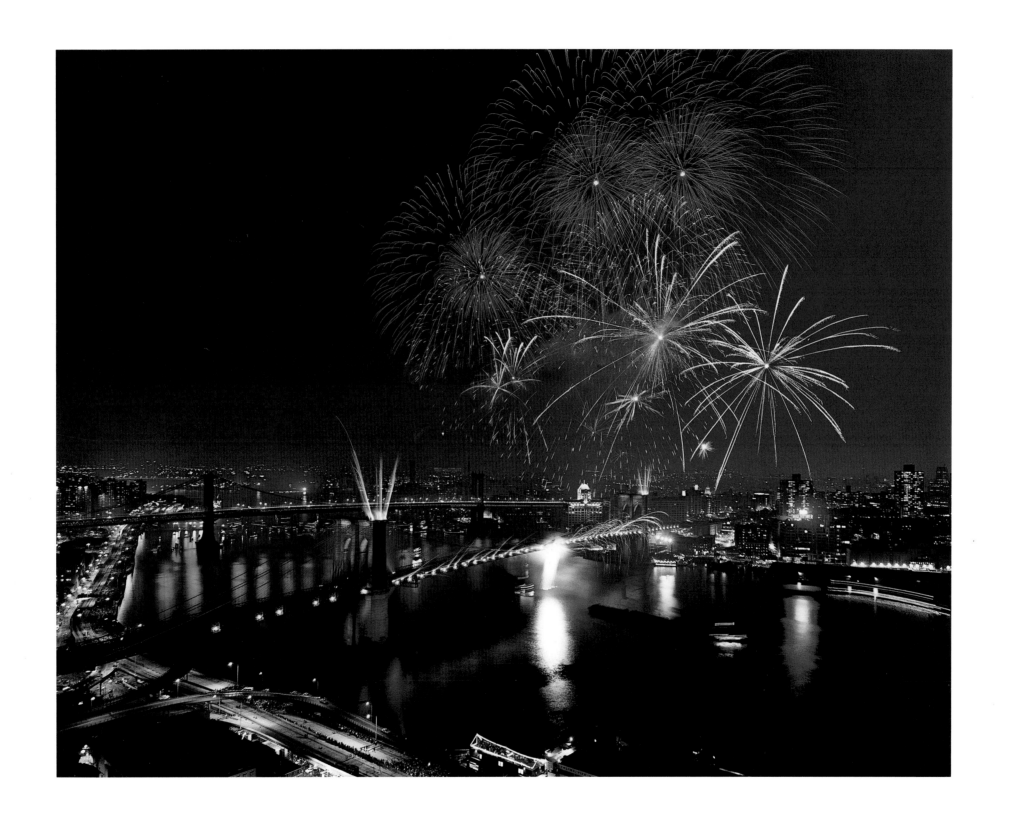

# 52

# THE BATTERY, NEW YORK HARBOR, AND THE QE2

## FROM 70 PINE STREET

## 1984

The chart has been read: 40°42′ North, 74°01′ West. About thirteen thousand vessels a year come in to this seaport, placed well inside its enormous bay. They say, as they always say of things, that it is the world's largest. This time they are right. They say that there are fifteen hundred square miles of land and water—exuberantly reckoning the port to extend to a twenty-five-mile radius of the city— and that a ship goes through the Narrows every twenty minutes. Greedy and innocent, one waits— if one comes by ship—for the curtain of sea haze to go up and reveal the stage. Vessels unseen for days now slant towards a harbor as yet out of sight. The bell buoy clangs along the Ambrose channel. The foghorns grunt and breathe out their profoundly mortal moans. And then the curtain rises on a shore that is mildly hilled and wooded, which in summer looks steamy, tropical, and ill-used and which presently rises to the rock Palisades of the Hudson. And there, in the middle of the scene, Manhattan stands tall and narrow, even more like a ship than a city, a structure of tiered decks, glassed in like a liner's, growing taller and taller until, if one were anchored, the thing looks as though it would run one down. Life in a city like that, we guess, will be ship life, confined, briskly run to order and signals. Somewhere among those millions of windows will be one's cabin. Small, it will be buzzing with noises overhead. There will be long journeys down corridors. There will be depths of solid machinery and wire. And here the fortune hunter, caught by his inability to grasp it all, finds his mind awash with metaphors. We have called Manhattan a ship and we shall think of a hundred more likenesses before we have done. This city has situation, as London and Paris have not; as Rio de Janeiro and Istanbul have, but Buenos Aires has not. Whatever happens, New York will always have that.

V. S. PRITCHETT
*New York Proclaimed, 1964*

# NEWTOWN CREEK AT DAWN
## FROM THE BROOKLYN-QUEENS EXPRESSWAY
### 1981

One of my favorite New York words is "Wadja-back." Not too many people ever hear it, unless they're in the right place at the right time (and how many people are ever in the right place at the right time?), but those who manage to be hear it constantly. "Wadjaback" means "Watch your back," and it is shouted throughout the night by men who push handcarts at Fulton Fish Market. It doesn't mean that you should literally watch your back; it applies equally to handcarts approaching from the front or sides. A handcart pusher coming right at you down an alley of haddock will look you in the eye and say, "Wadjaback" (The danger from a fast-moving, heavily loaded handcart is not to your back, anyway—it's to your ankles. The bottom of the cart has a metal platform that supports the cargo, and its leading edge is like a dull machete. A direct hit on one's ankles from behind would probably take care of both Achilles tendons simultaneously, sending the victim briskly to the pavement and burying him under six boxes of iced flounder.) But the reason I like "Wadjaback" is that it is rather personal and specific (*your back*) as opposed to the more common New York warning (or threat) "Watch it!" where the priority is on the "it" that is about to fall on you, strike you, or run over you, and the implication is that your damn body may dent the fender of the Mack truck. In a city where people are yelling at one all the time (or being sullen, and it sometimes seems there's no in-between), the texture of a yell becomes significant. "Wadjaback" really means get the hell out of the way, but it is too polite to say so. It acknowledges that you exist—that you have a back, and that you might wish to protect it. As warnings go, it's solicitous. "Wadjaback" would be a splendid substitute for those hollow, exhausted yet challenging imprecations "Have a nice day," "Merry Christmas," and "Happy New Year." There is no non-sense to "Wadjaback," yet it combines concern, a recognition of one's humanity and vulnerability, plus good solid advice. Wadjaback!

JAMES STEVENSON
"Wadjaback," 1977

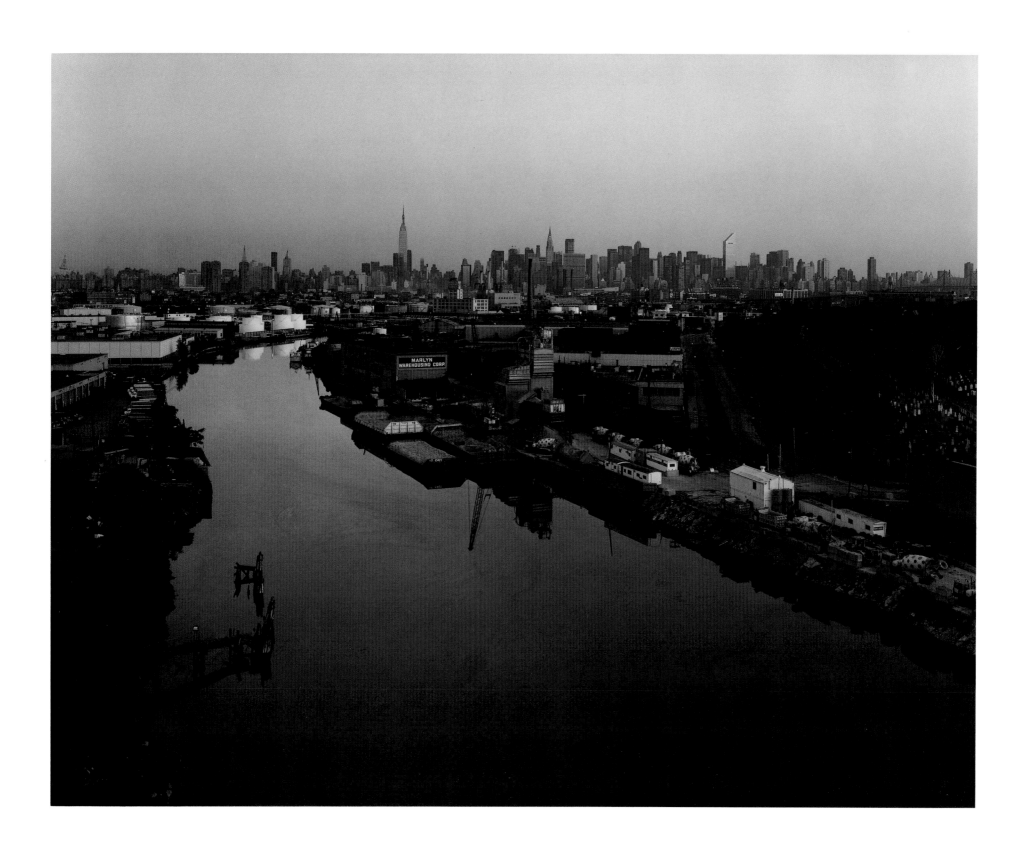

# THE MIDTOWN SKYLINE
# AND THE LONG ISLAND EXPRESSWAY
## FROM THE BROOKLYN-QUEENS EXPRESSWAY
### 1989

There are roughly three New Yorks. There is, first, the New York of the man or woman who was born here, who takes the city for granted and accepts its size and its turbulence as natural and inevitable. Second, there is the New York of the commuter—the city that is devoured by locusts each day and spat out each night. Third, there is the New York of the person who was born somewhere else and came to New York in quest of something. Of these three trembling cities the greatest is the last—the city of final destination, the city that is a goal. It is this third city that accounts for New York's high-strung disposition, its poetical deportment, its dedication to the arts, and its incomparable achievements. Commuters give the city its tidal restlessness; natives give it solidity and continuity; but the settlers give it passion. And whether it is a farmer arriving from Italy to set up a small grocery store in a slum, or a young girl arriving from a small town in Mississippi to escape the indignity of being observed by her neighbors, or a boy arriving from the Corn Belt with a manuscript in his suitcase and a pain in his heart, it makes no difference: each embraces New York with the intense excitement of first love, each absorbs New York with the fresh eyes of an adventurer, each generates heat and light to dwarf the Consolidated Edison Company.

E. B. WHITE
*Here is New York, 1949*

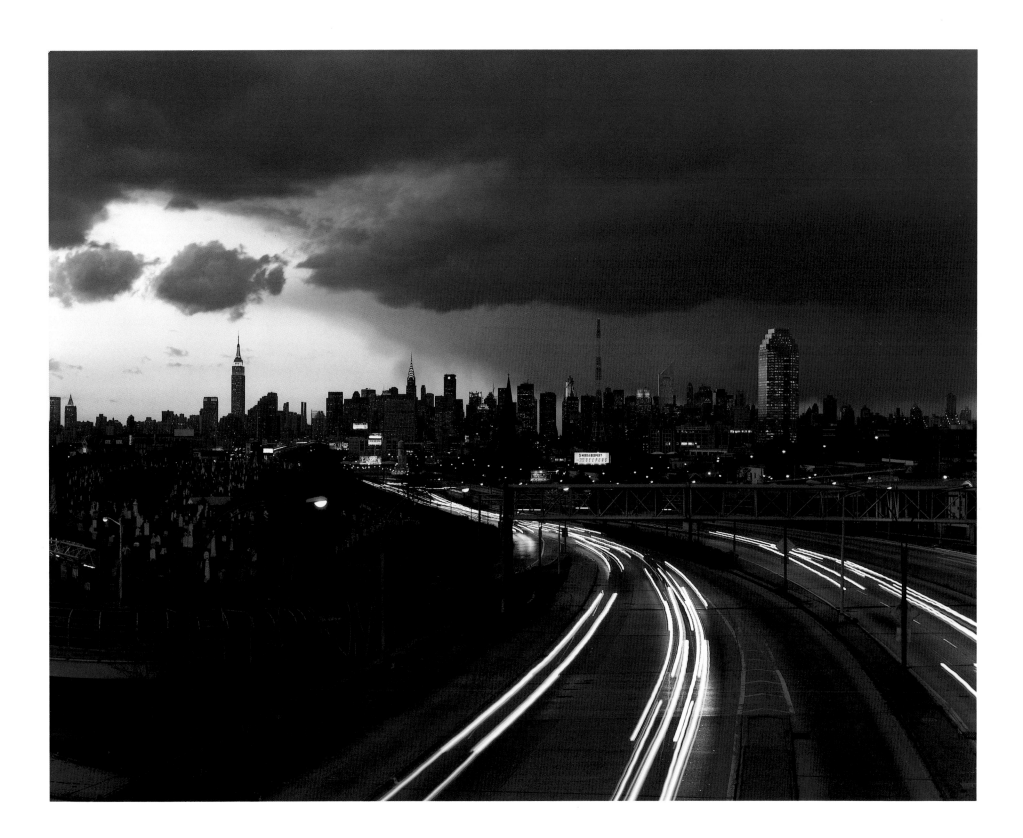

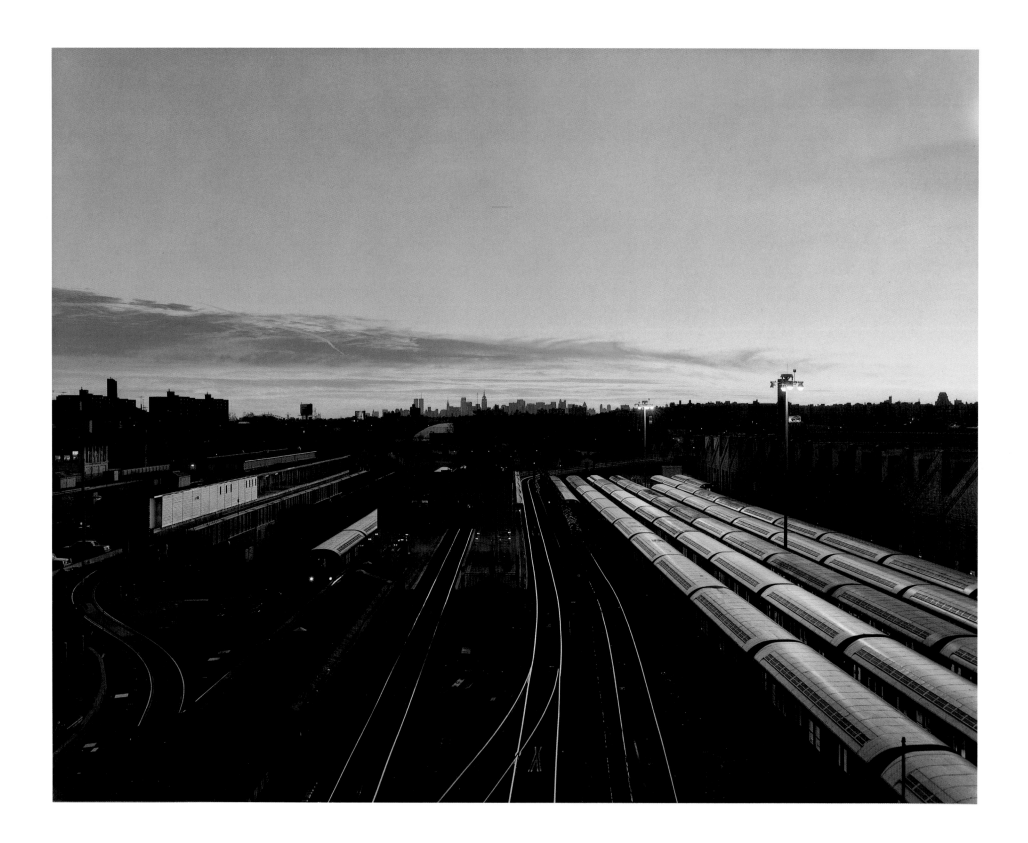

# THE MANHATTAN SKYLINE
## FROM THE EAST 180TH STREET SUBWAY STATION,
## THE BRONX
## 1989

A new book, *The Bruckner Octagon,* by E. Powers Jackson, has brought to light an astonishing and frightening phenomenon: a series of baffling disappearances within a general area of New York known as the Bruckner Octagon. This section, vaguely eight-sided, includes Bruckner Boulevard, the Cross Bronx Expressway, the Bronx-Whitestone Bridge, the Mosholu Parkway, and the Hutchinson River Parkway, as well as other major arteries, and extends to the east as far as Pelham Manor. For many years, travelers in this area have felt a strange uneasiness, without knowing quite why. Rumors of the odd disappearances have generally been discounted or ignored by the media and others. When, for example, it was noted, at the opening of the giant Co-op City apartment complex, in 1968, that there were only forty apartment buildings instead of the scheduled forty-one, the missing building was "written off" by authorities as a simple, though embarrassing, blueprint error. Today, in the light of other strange vanishings, the Co-op City case cries out for reexamination.

Although some experts draw parallels between the so-called Bermuda Triangle, in the Atlantic Ocean, and the Bruckner Octagon, there are important differences, suggesting that entirely separate forces are at work, or at least forces "wearing a different hat." Author E. Powers Jackson points out in his book that the Bruckner mysteries usually share one common thread: the disappearances involve solid, basically immovable objects, primarily real estate.

Jackson offers . . . some striking photographic evidence; although the pictures are in some cases fuzzy or vague, they are nonetheless disturbing.

EXAMPLE 1. Abandoned car. Regular travelers on the Hutchinson River Parkway and other arteries customarily pay little heed to abandoned cars on the roadside, noting only that each day these vehicles have fewer and fewer parts, until one day they are actually "gone." This phenomenon is routinely attributed to vandalism, but a new theory suggests that something much more puzzling—indeed, alarming—is involved.

EXAMPLE 2. Author Jackson states that six feet of the Bronx River Parkway near Gun Hill Road "vanished" during the night of March 11, 1971. Highway authorities deny this but admit "we have no way of knowing," adding, "In any case, there's always some shrinkage during cold weather."

EXAMPLE 3. [A certain] roadside eatery stood at the southeast corner of Van Cortlandt Park until 7:29 A.M. of June 2, 1973, according to Jackson. Onetime residents of the area hold conflicting views. Some state that Howard Johnson's restaurants "all look alike," while other residents simply "don't want to get involved."

The evidence goes on. Extraterrestrial mischief? Satanic intervention? Psychokinetic maneuverings? Author Jackson suggests several hypotheses, including "soft spots" in the Bronx (some experts think that a certain patch of concrete in a field near the Hutchinson River Parkway is the actual roof of the missing Co-op City building), molecular stretch (a gradual separation of particles until they no longer form a recognizable mass; in such an instance, a Howard Johnson's would "occupy" an area of several thousand miles, and hence be unidentifiable at any particular point), and even structural-fatigue interchange, or SFI (a process believed to occur when a building, for example, can no longer "hack it" as a car wash and opts for a "simpler" existence as, say a beach plum).

JAMES STEVENSON
"The Bruckner Octagon," 1975

# GRAND CENTRAL STATION

## 1991

The floor itself was a great half-barrel, the ceiling a grid of steel. All this was warmed by nearly visible streams of air rising above the lights, which were the stars of the constellations in the great vaulted roof of Grand Central Station—recently rebuilt with the notion of installing the sky indoors to shine permanently and in green....The real stars blazed like faraway white flares and put to shame the imitations of the station ceiling: there were pinwheels of fire, round phosphorescent spirals of light....the snow swirled in sparkling chains, their motion suspended and stilled, as in the stars. Deep within the high blazing tunnels, motion and stillness met and fused. The wind shrieking across the drifts on the station roof turned the snow into a white vapor that flattened into spinning vortexes. Seen from afar, the city's pulsating lights were like stars, and the distant avenues and high plumes of steam that curled and twisted were like the star roads themselves.

MARK HELPRIN
*Winter's Tale,* 1983

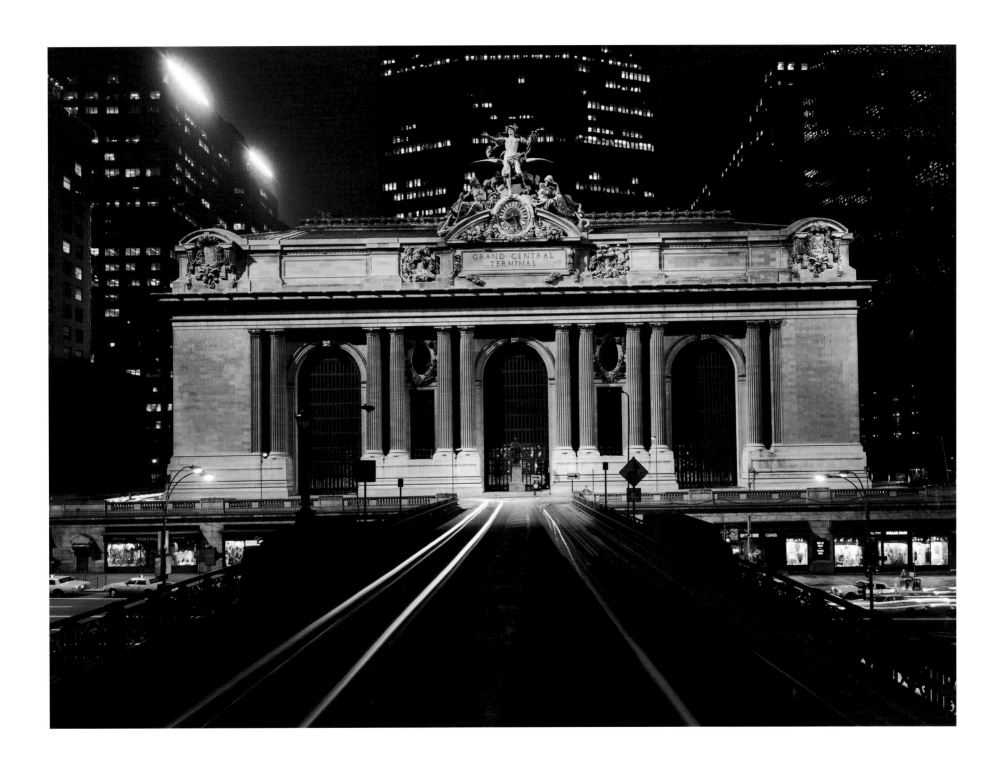

# THE LOWER MANHATTAN SKYLINE AND THE WILLIAMSBURG BRIDGE

## 1981

*I was asking for something specific and perfect for my city,*
*Whereupon, lo! upsprang the aboriginal name!*

*Now I see what there is in a name, a word, liquid, sane, unruly,*
*musical, self-sufficient;*
*I see that the word of my city is that word up there,*
*Because I see that word nested in nests of water-bays, superb, with tall*
*and wonderful spires,*
*Rich, hemm'd thick all around with sailships and steamships—an island*
*sixteen miles long, solid-founded,*
*Numberless crowded streets—high growths of iron, slender, strong, light,*
*splendidly uprising toward clear skies;*
*Tide swift and ample, well-loved by me, toward sundown,*
*The flowing sea-currents, the little islands, larger adjoining islands,*
*the heights, the villas,*
*The countless masts, the white shore-steamers, the lighters, the ferry-*
*boats, the black sea-steamers well-model'd;*
*The down-town streets, the jobbers' houses of business—the houses of business*
*of the ship-merchants, and money-brokers—the river-streets;*
*Immigrants arriving, fifteen or twenty thousand in a week;*

*The carts hauling goods—the manly race of drivers of horses—the brown-*
*faced sailors;*
*The summer air, the bright sun shining, and the sailing clouds aloft;*
*The winter snows, the sleigh-bells—the broken ice in the river, passing*
*along, up or down, with the flood-tide or ebb-tide;*
*The mechanics of the city, the masters, well-form'd, beautiful-faced,*
*looking you straight in the eyes;*
*Trottoirs throng'd—vehicles—Broadway—the women—the shops and shows,*
*The parades, processions, bugles playing, flags flying, drums beating;*
*A million people—manners free and superb—open voices—hospitality—the*
*most courageous and friendly young men;*
*The free city! no slaves! no owners of slaves!*
*The beautiful city, the city of hurried and sparkling waters! the city of*
*spires and masts!*
*The city nested in bays! my city!*
*The city of such women, I am mad to be with them! I will return after*
*death to be with them!*
*The city of such young men, I swear I cannot live happy, without I often*
*go talk, walk, eat, drink, sleep, with them!*

WALT WHITMAN
"Mannahatta"

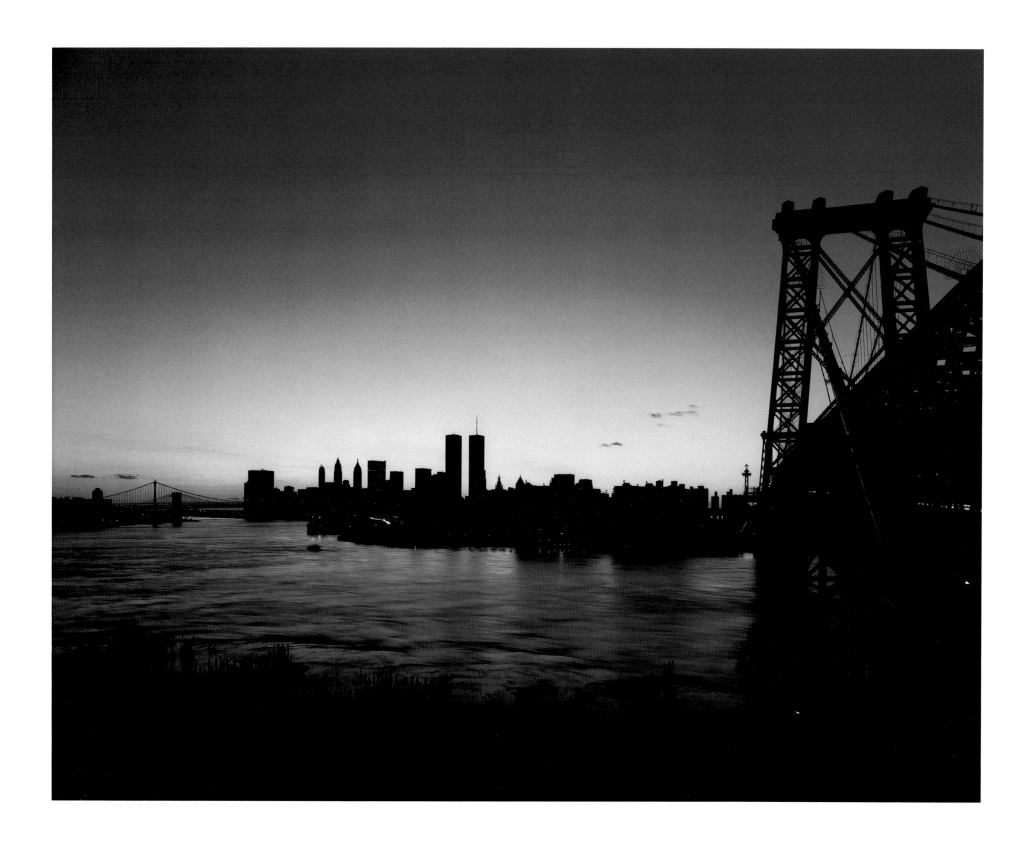

# ACKNOWLEDGMENTS

An exhaustive effort has been made to locate all persons having any rights or interests in material and to clear reprint permissions. If any required acknowledgments have been omitted or any rights overlooked, it is by accident and forgiveness is requested. Publisher shall include any necessary revisions in future editions.

Excerpts from *Winter's Tale* by Mark Helprin, copyright © 1983 by Mark Helprin, reprinted by permission of Harcourt Brace Jovanovich, Inc., George Weidenfeld & Nicolson Limited, and The Wendy Weil Agency, Inc.

Excerpt from *Portrait of New York* by Cecil Beaton. Granted by permission of the Publishers, B.T. Batsford Ltd, London.

Excerpts from *New York Proclaimed* by V. S. Pritchett. Reprinted by permission of Peters Fraser & Dunlop Group Ltd.

"New York: Matter Triumphalis" and "The Resignation of New York" from *Mirrors of New York* by Benjamin de Casseres. Copyright 1925 by Benjamin de Casseres. New York: Joseph Lawren.

Excerpts from "No Door" used by permission of Charles Scribner's Sons, an imprint of Macmillan Publishing Company, and Paul Gitlin, Administrator CTA of the Estate of Thomas Wolfe, from *Death to Morning* by Thomas Wolfe. Copyright 1933 by Charles Scribner's Sons; renewal copyright © 1961 by Pincus Berner.

Excerpts from *When the Cathedrals Were White* by Eduard Le Corbusier, copyright 1947 by Harcourt Brace Jovanovich, Inc. and renewed 1975 by Francis E. Hyslop, Jr., reprinted by permission of the publisher.

"A Mournful Old Building," "In the Broadway Cars," and "The Roof Gardens and Gardeners of New York" are reprinted by permission of New York University Press from *The New York City Sketches of Stephen Crane and Related Pieces,* edited by R.W. Stallman and E. R. Hagemann. Copyright © 1966 by New York University.

"Brooklyn Bridge" by Vladimir Mayakovsky from *Modern Russian Poetry: An Anthology with Verse Translations,* edited and with an Introduction by Vladimir Markov and Merrill Sparks. Copyright © 1966, 1967 by MacGibbon & Kee Ltd. Reprinted by permission of Grafton Books.

"Brooklyn Bridge at Dawn" from *New Poems* by Richard le Gallienne, published by Dodd, Mead & Company.

Excerpt from *Magical City: Intimate Sketches of New York* by Arthur Bartlett Maurice, reprinted with permission of Charles Scribner's Sons, an imprint of Macmillan Publishing Company. Copyright 1935 by Charles Scribner's Sons; renewal copyright © 1963.

"New York at Night" from *The Complete Poetical Works of Amy Lowell* by Amy Lowell. Copyright © 1955 by Houghton Mifflin Co. Copyright © 1983 renewed by Houghton Mifflin Co., Brinton P. Roberts, and G. D'Andelot Belin, Esquire.

Excerpts from *Imperial City: New York* by Geoffrey Moorhouse. Copyright © 1988 by Geoffrey Moorhouse. Reprinted by permission of Henry Holt and Company, Inc. and Hodder & Stoughton Ltd. (Published in Great Britain as *Imperial City: The Rise and Rise of New York*.)

Excerpt from "Best Views of the New City of Lights" by Paul Goldberger. Copyright © 1983 by The New York Times Company. Reprinted by permission.

Excerpt from "The Cerf-board—The Bowery" by Bennett Cerf, *This Week,* August 3, 1952. Copyright 1952 by United News P. Magazine Corp., New York.

Excerpts from *Metropolis: New York as Myth, Marketplace, and Magical Island.* Copyright © 1986 by Jerome Charyn. Reprinted by permission of The Putnam Publishing Group.

"Chapin of the *World*" from *City Editor* by Stanley Walker. Copyright 1934 by Stanley Walker. New York: Frederick A. Stokes Company.

Excerpt from *Uncle Samson* by Beverley Nichols. Reprinted by permission of New York Unversity Press from *Mirror for Gotham: New York as Seen by Contemporaries from Dutch Days to the Present* by Bayrd Still. Copyright © 1956 by New York University.

Excerpts from *Central Park: A History and a Guide* by Henry Hope Reed and Sophia Duckworth. Copyright © 1967 by Henry Hope Reed and Sophia Duckworth. Reprinted by permission of the authors.

Excerpts from "Here is New York" from *Essays of E. B. White.* Copyright 1949 by E. B. White. Reprinted by permission of Harper & Row, Publishers, Inc.

"House," "Wadjaback," and "The Bruckner Octagon" by James Stevenson originally appeared in slightly different form in *The New Yorker* and in his book *Uptown Local, Downtown Express.* Copyright © 1983 by James Stevenson. Reprinted by permission of the author and the Liz Darhansoff Literary Agency.